POSTCARD H

Historic Wilson

IN VINTAGE POSTCARDS

J. Robert Boykin III

ARCADIA

First published 2003
Reprinted 2004

Published by Arcadia Publishing
Charleston SC, Chicago IL, Portsmouth NH, San Francisco CA

Printed in Great Britain

Library of Congress Catalog Card Number: 2002116275

For all general information contact Arcadia Publishing at:
Telephone 843-853-2070
Fax 843-853-0044
E-Mail sales@arcadiapublishing.com

For customer service and orders:
Toll-Free 1-888-313-2665

Visit us on the internet at http://www.arcadiapublishing.com

Dedicated to Susan and Dillon Boykin and all my Wilson kin.

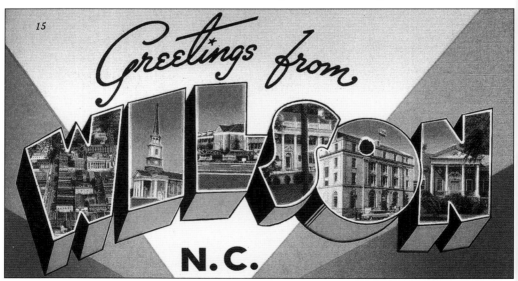

A greeting card shows an aerial view of Wilson, including the First Presbyterian Church, Eastern North Carolina Tuberculosis Sanatorium, Dr. and Mrs. Mallory A. Pittman Home, post office, and the Wilson County public library. Each of these scenes was made into individual cards. The back of the card reads, "Wilson was called the prettiest village in the coastal plain by the late Josephus Daniels, former Navy Secretary and Ambassador to Mexico as he wrote in his autobiography." Daniels grew up in Wilson.

CONTENTS

ACKNOWLEDGMENTS

It is hard to have lived in a place for a lifetime and not have a multitude of people that have played a part in the fruition of a book. But on a broader spectrum, my early ancestors laid groundwork for my interest in Southern history. I doubt that early pioneer families of the area from whom I descend, including the Boykin, Lamm, Woodard, Peele, Pearson, Battle, Fort, Coppage, Barnes, Fulghum, Williamson, Nichols, Vick, Bardin, Dew, Whitehead, Raper, Joyner, Eatmon, Horn, Deans, Ferrell, Thorne, and Flowers families, ever thought they would be the seeds for *Historic Wilson in Vintage Postcards*.

On a narrower spectrum, many good teachers have influenced my interest in history and Wilson. These include Mrs. Katherine B. Fleming, Dr. Francis Collins, and Mr. Bill Weir at Fike High School; Dr. William S. Powell and Dr. William M. Geer at the University of North Carolina at Chapel Hill; and Dr. William E. Tucker, Dr. W. Jerry MacLean, and Dr. Allen R. Sharp at Barton College.

Many citizens have contributed to the written history of Wilson. James Dempsey Bullock and Daisy H. Gold should be recognized for their past contributions. In recent times, Hugh B. Johnston Jr. (a mentor of mine for many years), J. Marshall Daniel Jr., Henry and Sue Evans Powell, Dr. Patrick Valentine, and Joan Howell of Lucama, North Carolina have all helped and assisted me, sometimes knowingly and sometimes not.

I started collecting postcards in the seventh grade. My family always encouraged my interest in Wilson history, particularly my father, J.R. Boykin Jr. (1922–1981). I vividly remember him bringing me the 1879 Mayo Map of Wilson when I was in the eighth grade. I wish I could name all the family and friends that have encouraged and prodded this love of mine—you know who you are and many thanks are in order. Not enough can be said about the other postcard collectors, particularly Sarah Manning Pope of Morehead City, North Carolina and Willard Jones of Ahoskie, North Carolina, who let me have their entire collection of Wilson postcards for my own collection. If it were not for Pope and Jones this book would not have been printed. Thanks are also in order for Durwood Barbour of Raleigh, North Carolina; Doug Matthews of Rocky Mount, North Carolina; Louis Martin of Washington, North Carolina; Steve Massengill of North Carolina Archives and History; and Phil Perkinson of Norlina, North Carolina; all of who have found cards for me. My assistant Donna Ellington Smith also deserves recognition, as does Sandra Lamm Homes of Wilson Tourism and Visitors Center.

Finally, a special thank you goes to my wife Susan Mewborn Boykin, my partner in historical and genealogical research and in life. My name is on the book, but she has been standing beside me all the way.

> To be a North Carolinian, either by birth, marriage, adoption, or even on one's mother's side is an introduction to any state in the Union, a passport to any foreign country, and a benediction from the Almighty God.
>
> *Anonymous*

Historic Wilson

IN VINTAGE POSTCARDS

The top postcard on this page is postmarked 1907 and the bottom card is from the 1930s. The latter shows a downtown street scene including the Wilson County Courthouse, the First Union National Bank, the Cherry Hotel, the United States Post Office and Federal Building, the Wilson County Courthouse, Wilson Country Club, and the Wilson Municipal Building. The message reads "Remember me in your dreams, remember me in your prayers, remember there's someone who loves you who is away and can't be there. JTE." The top left of the bottom card shows the interior of a tobacco warehouse as a tobacco auction occurs. The bottom right corner shows Mr. C.D. West with three workers in the tobacco field.

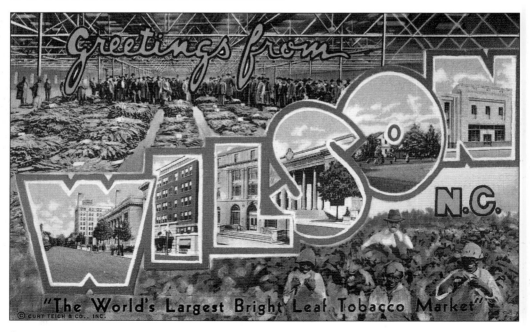

INTRODUCTION

The village of Wilson, North Carolina was incorporated in 1849. Six years later in 1855, the county was formed from parts of Nash, Wayne, Johnston, and Edgecombe Counties. Wilson was named for Mexican War hero Gen. Louis Dickens Wilson, who had died during the war. The town had originally been two separate villages. One was Toisnot, located around the train depot. The other was Hickory Grove, near the Toisnot Primitive Baptist Church, which is located where the city-owned parking lot is now (in front of Jimmy Womble's W.W. Furniture and Appliances on Tarboro Street). The church was founded in 1756 and moved to the Tarboro Street site in 1802.

Native Americans lived in what is now Wilson County for generations. The Tuscarora Indians lived here in the 16th, 17th, and early 18th centuries and left in 1713 after the great battle of Fort Nooherooka, just south of Stantonsburg in Greene County. The first recorded contact with a European was John Lawson, the explorer who came through the area in 1700–1701. The local Indian village was named Tosneoc (meaning "tarry not" or "halting place"). The word is still used today with Toisnot Swamp, Toisnot Township, Toisnot Middle School, and Toisnot as the old name for Wilson and Elm City. People began moving into the area with John Thomas in 1741, Francis Rountree in the early 1740s, Arthur Dew in 1749, Benjamin Boykin in 1752, and brothers John and Capt. Jacob Barnes in 1761 and 1762. Africans also came early, the first recorded with John Thomas in 1741.

During the Revolutionary War, British troops under Gen. Charles Cornwallis traveled through the area on a trek north from Wilmington to Yorktown. He spent the night at John Eatmon's home and left his eyeglasses and handkerchief, still belonging to the descendants of John Eatmon. In May 1781, Col. Banastre Tarleton led an advance party that met resistance at Peacock's Bridge near Stantonsburg. There is a North Carolina Highway Historical marker for this event at the site.

There was not much fighting in the county during the Civil War in the 1860s, but many soldiers came from Wilson County families. A Confederate hospital was created at the Wilson Collegiate Institute and the railroad transferred many soldiers towards the North or South. There were dark days after the war locally.

Wilson was known for its fine educational institutions, central location, and accessible roads. The establishment of the tobacco market in 1890 gave the town the title of "The World's Largest Tobacco Market." The Civil War brought hard times for the county and the economic situation did not improve until the coming of the "golden leaf." Tobacco brought money, employment, new residential areas, new businesses, hotels, and industry. During this period, the postcard was introduced to the American public. Postcards are privately printed, whereas cards printed by the government are called postal cards. The following list will help an individual to identify and date a postcard:

1. Pioneer cards (1893–1898) are rare. They are often labeled "souvenir postcards."
2. Private mailing cards (1898–1901) are rare. The term "private mailing card" is printed on the address side, normally with "Authorized by Act of Congress of May 19, 1898."

3. Undivided Backs are dated from 1901 to 1907. Messages were not allowed with the address, so backs were not divided.
4. Divided Backs are dated from 1907 to World War I. The United States postal service approved the divided backs, which allowed a message and address on the same side. These were published in England and Germany.
5. White borders appeared after World War I until the 1930s. During this time, many, but not all, postcards had white borders. Most of these cards were published in the United States.
6. Linens appeared in the 1930s and 1940s. These are generally more common cards. They have a rough finish, with a texture similar to linen, and were made using paper with high rag content.
7. Chromes arrived in the 1940s, and are around today. Most look like photographs and are printed in color.
8. Real photographic postcards (1900s–present) are printed on photographic paper, and the words "postcard" and "stamp box" are printed on the back. The earlier real photographic postcards are quite rare and sometimes one of a kind.

Many of the Wilson postcards were made by photographers O.V. Foust, J.W. Gill, Bayard Wootten, Francis Winstead and son, Alonza Winstead, the Alley Family (later of Tarboro, North Carolina), and Raines & Cox, which included Charles Raines and Guy Cox. Many were published by the Asheville Publishing Company, Curt Teich Publishing Company, and Tichnor Brothers. All the postcards shown are in my own collection unless otherwise stated.

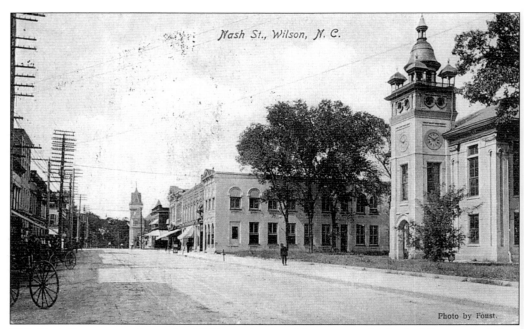

This Nash Street scene shows the 1857 courthouse with a new roof. The building to the left of the courthouse is the National Bank of Wilson, and the First Baptist Church is at the end of the street. Note the electrical wiring and dirt streets. The card is postmarked 1907. The county appointed five commissioners, including Alfred Boykin, Macon Moore, Dr. A.G. Brooks, Asa Barnes, and William Barnes, to acquire land and build a new courthouse for the county seat.

One
DOWNTOWN SCENES

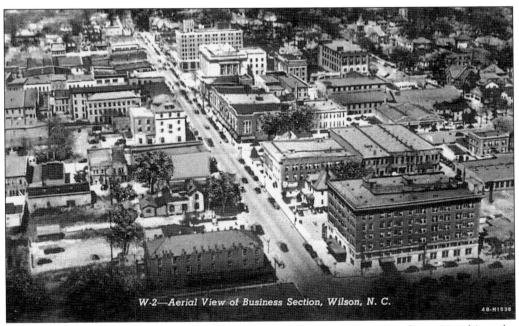

W-2—Aerial View of Business Section, Wilson, N. C.

This aerial view of the downtown business section is from the 1930s. The Cherry Hotel is at the bottom right. Wilson's past slogans have included the "City of Trees," "The Town to Tie To," "Wide-Awake Wilson," and "Discover our Treasures and Simple Pleasures." Wilson is also known for its cotton market, tobacco market, barbecue restaurants, antique markets, educational institutions, and beautiful residential areas.

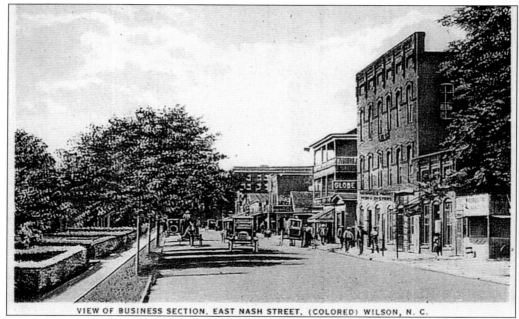

VIEW OF BUSINESS SECTION, EAST NASH STREET, (COLORED) WILSON, N. C.

East Nash Street shows the vibrant and active African-American business community. The three-story Odd Fellows Hall was built in 1894 and used by the Hannibal Lodge No. 1552. It was built by Sam H. Vick, a noted black businessman and postmaster. Maynard's Fish Market was on the first floor and the Globe Theater was next door. The African-American owned Commercial Bank of Wilson, founded in 1921, was in this block.

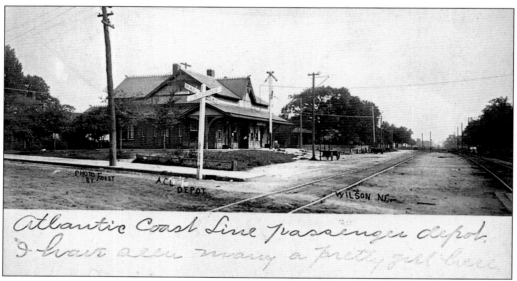

This rare postcard of the Atlantic Coast Line Wilson Depot, built in 1893, shows the Victorian and almost residential look of the train depot. This was torn down when the current Spanish Mission Revival train station was built in 1923. Note the two railroad tracks. The message reads, "I have seen many a pretty girl here." This real photograph, taken by O.V. Foust, dates from *c.* 1910.

10

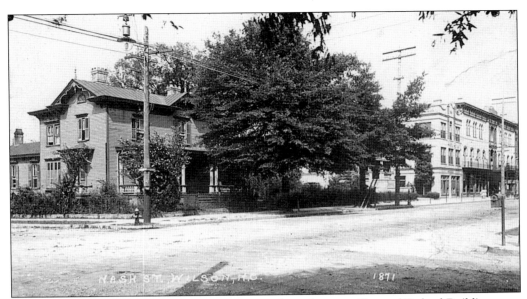

This card, postmarked 1914, shows the residence where the post office and Federal Building were later built. It is now Imagination Station, a science museum for children. The next two buildings are the Wilson Sanatorium and the Briggs Hotel. The home belonged to Herbert Ward. The message reads "Hello George, am in Wilson jerking soda now. Have been here two weeks. Think I will try here for a while. May drop down to see you before long. Slick."

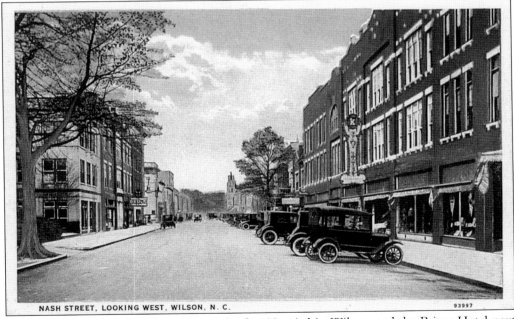

On the left are the Wilson Sanatorium, the first Hospital in Wilson, and the Briggs Hotel next door. On the first floor of the hotel were the Turlington and Moore's Drug Store. Dr. Charles E. Moore and Dr. Albert Anderson opened the hospital in 1896. Dr. Elijah Thomas Dickinson bought an interest in 1902.

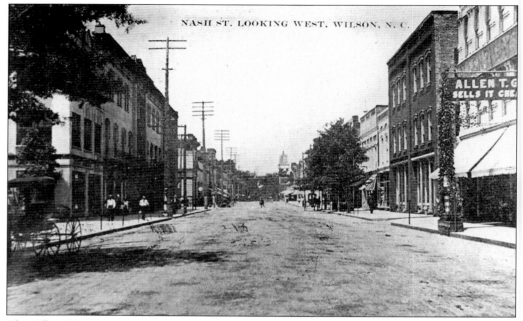

The Allen T. Gay Department Store is in front of the hospital and hotel, and the First Baptist Church is at the end of the street. The store was established in 1909 and was known by the slogan, "Allen T. Gay sells it cheaper."

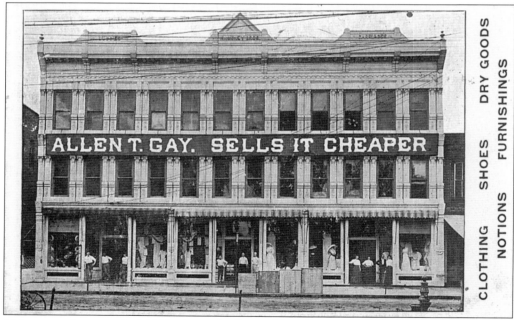

This postcard, postmarked 1910, shows the front of the Allen T. Gay Department Store with the employees out front. They sold clothing, shoes, dry goods, notions, and furnishings. It later became the Gay Brothers, owned by Allen T. and Charles Gay.

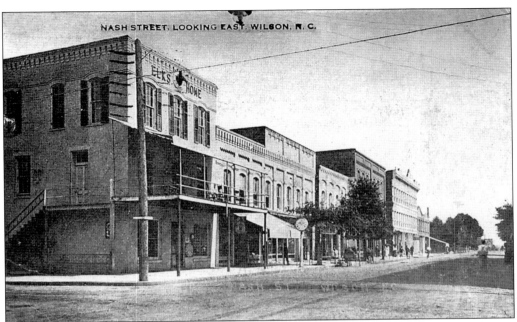

This postcard, postmarked 1910, shows the Elks Home. This building stands where the Planters Bank was later built and is currently occupied by the City of Wilson as an extension to the municipal building. The clock is in front of Privett's Jewelry Store next to the Herrings Drug Store, which was established in 1897. The current Elks Lodge was chartered on October 21, 1941 as a patriotic, fraternal organization whose charitable work is directed toward youth.

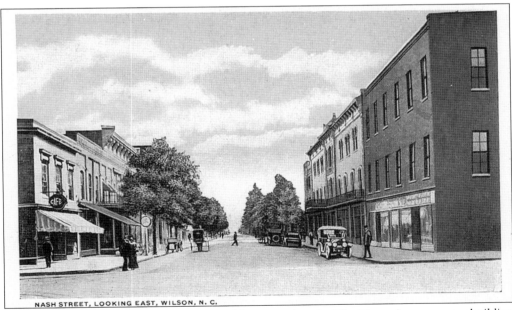

NASH STREET, LOOKING EAST, WILSON, N. C.

This is the same block as the above postcard but note that the Elks Home is now a new building with a café sign. The clock is still in place. The Briggs Hotel is to the right with wrought iron metal work between the first and second floors. This card is postmarked 1919.

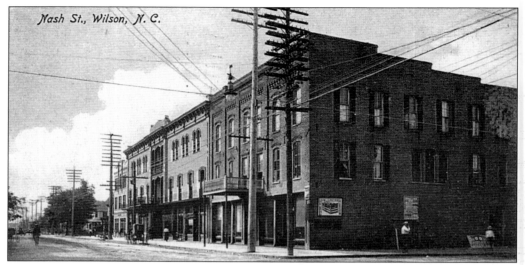

Nash St., Wilson, N. C.

The Briggs Hotel in this 1908 card was built in 1873 by B.F. Briggs. It was a first-class hotel with a barbershop, drugstore, and dining room downstairs and 85 rooms, many of which had private bath connections. Many commercial salesmen stayed there. It was a popular gathering spot for locals and travelers. The building was designed by E.G. Lind of Baltimore and was razed in 1955. Briggs was clerk of court and sheriff from 1868 to 1874. The hotel is most associated with his son, Roscoe Briggs (1859–1933), who ran the hotel for many years.

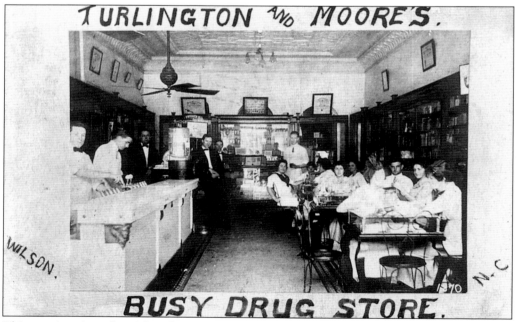

TURLINGTON AND MOORE'S.

WILSON.

N-C

BUSY DRUG STORE.

This rare interior of a Wilson business shows the Turlington and Moore's "busy drug store," located in the Briggs Hotel. It was established in 1906 with R.A. Turlington as president and treasurer, and L.S. Edwards as secretary. The soda fountain was extremely popular with Wilson residents. By 1916, E.S. Morrison had bought into the business and the drug store was renamed Turlington and Morrison.

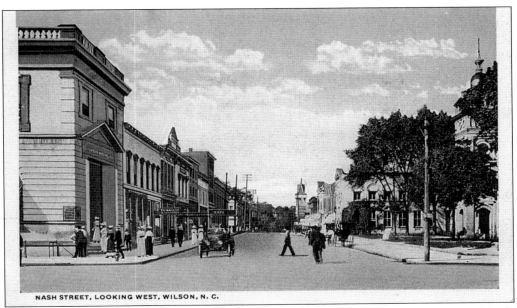

NASH STREET, LOOKING WEST, WILSON, N. C.

This C.T. American Art Card shows Branch Bank to the left, later known later as BB&T. BB&T is the oldest bank in continuous existence in North Carolina. It was headquartered in Wilson until a recent move to Winston-Salem. The bank was located in front of the courthouse and is home to the Arts Council of Wilson and the Annie Draughn Boykin Art Gallery.

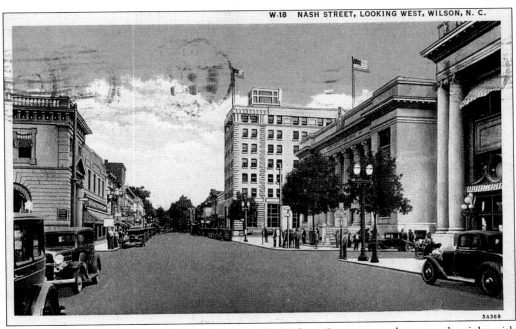

W-18 NASH STREET, LOOKING WEST, WILSON, N. C.

This 1940 postcard shows the Planters Bank and the Wilson County courthouse to the right with the then tallest building in town, the First National Bank of Wilson. On the left are Branch Bank and McLellan's 5-and-10 cent store, which opened about 1916. The message reads "This is a pretty little town and is the center of NC Tobacco Auctions. Full of tobacco warehouses. Karl."

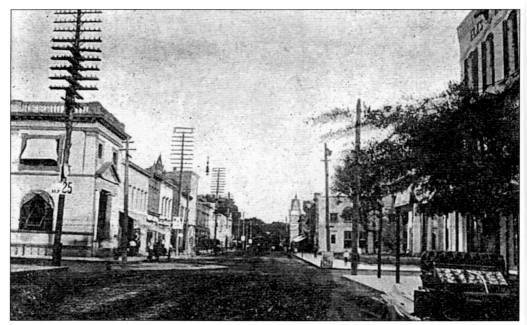

Standing in front of Herring's Drug Store, this 1906 card shows the Elks Home to the right with the Elk head and Branch Bank to the left. Note the bank has its windows open to cool off the interior. Branch Bank later became BB&T. Locals often say BB&T stood for "butter beans and taters."

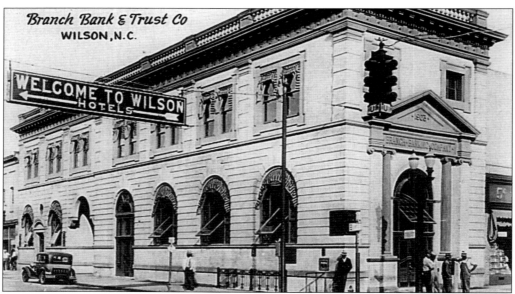

This photograph is of Branch Bank and Trust. The bank, founded in 1872, constructed this building in 1903. It is known as the oldest bank in North Carolina in continuous existence and is now headquartered in Winston-Salem. Note the neon sign pointing the arrow to the Wilson hotels. The bank was headquartered in Wilson until the mid-1990s and is now a regional Southeastern bank.

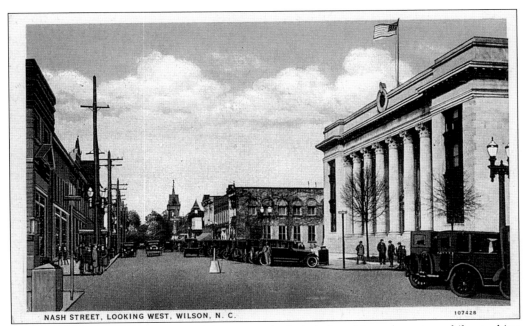

NASH STREET, LOOKING WEST, WILSON, N. C. 107428

The Courthouse was built in 1924 in a neo-classical design. Note the automobiles parking straight in and the wooden stop sign in the middle of the Nash and Goldsboro Street intersection

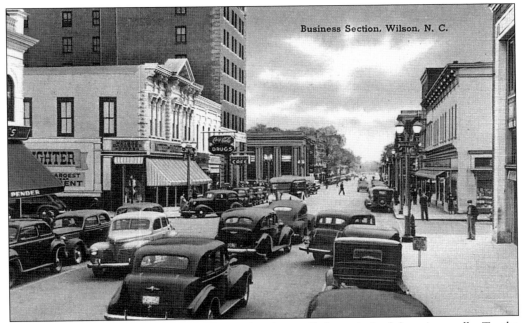

Business Section, Wilson, N. C.

The business section of Wilson was busy and active until the arrival of shopping malls. To the left are Pender Groceries, the Mother & Daughter Store, and the local skyscraper, First National Bank of Wilson. Note the school bus coming towards the intersection of Tarboro and Nash Streets, probably made by Hackney Brothers Body Company of Wilson.

17

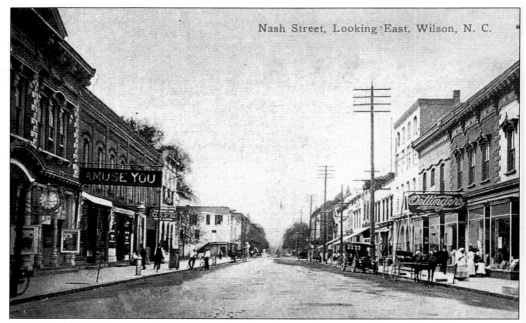

Nash Street, Looking East, Wilson, N. C.

This July 15, 1913 postcard sent to New York City says, "Hoping all is well and that it ain't as warm in New York as it is here." The clock to the left is at Burden's Jewelry and Watchmakers, which appears to have art for sale on the front of the store. To the right is Oettinger's Department Store, founded in the 1850s by one of the earliest Jewish families in Wilson.

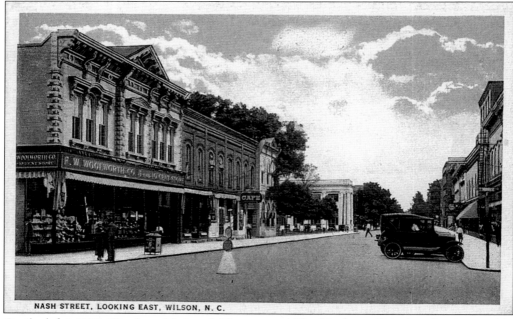

NASH STREET, LOOKING EAST, WILSON, N. C.

On the left is F.W. Woolworth's 5-and-10 cent store. The Mother & Daughter Store moved in later. Planter's Bank is at the end of the street. The county of Wilson owns the building now and plans to raze it in the near future.

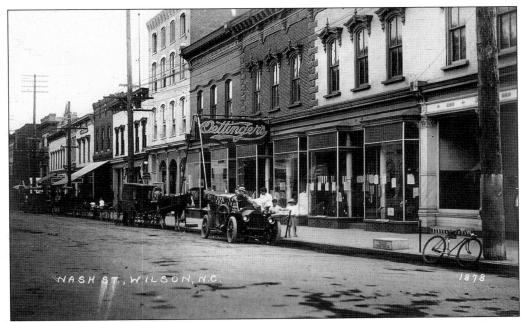

NASH ST., WILSON, N.C. 1878

Oettinger's Department Store was located in the courthouse block for many years. The owners were related to the Rosenthal's of Wilson and Weil family of Goldsboro. The bottom card, postmarked 1929, shows the expanded Oettinger's Department Store, which occupied several buildings on the block. Oettinger's was known as "the dependable store." One of the oldest Jewish families in Wilson, they were leaders in establishing the public school system, chamber of commerce, Wilson Country Club, and Atlantic Christian College. The store was founded just before the Civil War. Several members of the family fought and died for the Confederacy. The store closed in the 1970s.

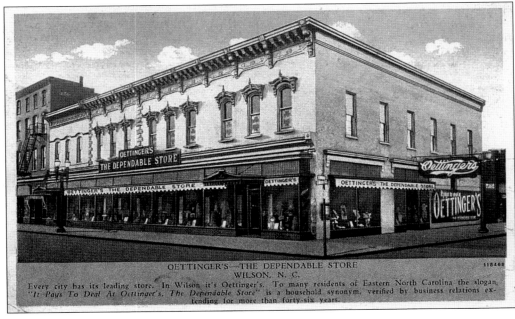

OETTINGER'S—THE DEPENDABLE STORE
WILSON, N. C. 115468
Every city has its leading store. In Wilson it's Oettinger's. To many residents of Eastern North Carolina the slogan,
"It Pays To Deal At Oettinger's, The Dependable Store" is a household synonym, verified by business relations extending for more than forty-six years.

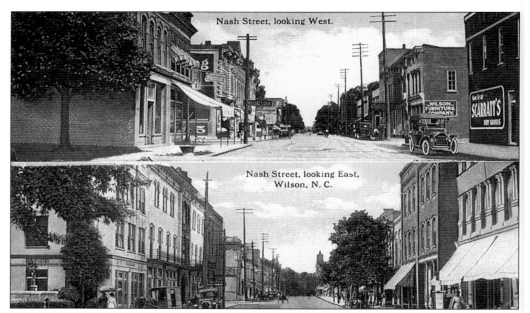

This top portion of this 1913 double-card street scene shows where the Boykin Cultural Center is looking towards the courthouse. Pender's Grocery is where the awning is to the left and Scarratt's Dry Goods, owned by Charles Scarratt, is to the right. The bottom shows the Wilson Sanatorium and Briggs Hotel to the left.

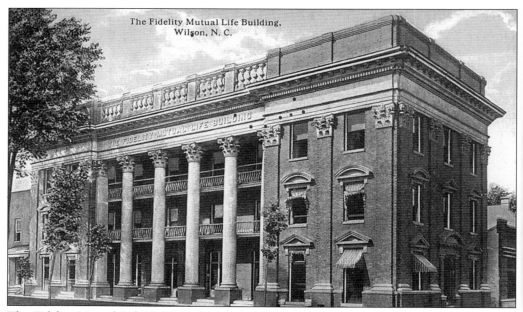

The Fidelity Mutual Life Building, later called the Gold Professional Building, was behind the courthouse. Built in 1910, this was one of Wilson's finest neo-classical buildings and it was torn down for the new jail in 1977. It was designed by Charles C. Benton (1887–1960) and Solon B. Moore (1872–1930).

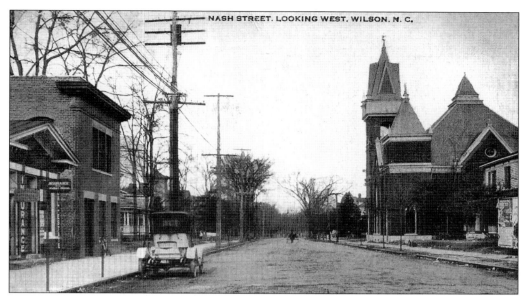

NASH STREET, LOOKING WEST, WILSON, N. C.

This view is from the front of the Boykin Cultural Center (Wilson Theatre) looking towards the First Baptist Church, where First Citizens Bank is now located. This was the second building for the First Baptist Church. This is the southeast corner of Nash and Pine Streets.

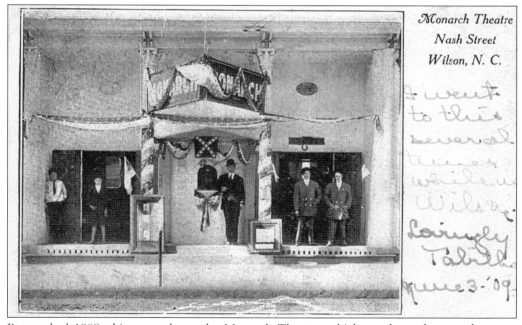

Monarch Theatre
Nash Street
Wilson, N. C.

Postmarked 1909, this scene shows the Monarch Theater, which was located across the street from the current Boykin Cultural Center. This theatre did not last as long as it is not listed in the 1912–1913 city directory. The message on the back reads, " Brother & I appreciate your kind invitation to the lawn party so much. We can't go. The nights are so rainy and bad we are afraid to attempt to go. Hope the weather will not be too bad to have it. I dreamed about you last night. Come over to see me."

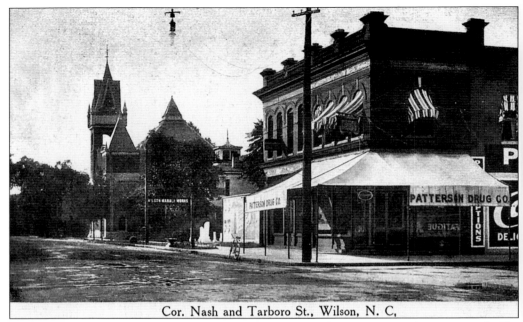

Cor. Nash and Tarboro St., Wilson, N. C.

Patterson Drug Store was on the corner of Nash and Tarboro Street in this 1913 card. The Wilson Marble Works was to the left and followed by the First Baptist Church. The message on the card reads, "Hello little girl, we are having a fine time in this old town. We beat ACC (Atlantic Christian College) 1 to 0. That wasn't bad was it. R.S.S."

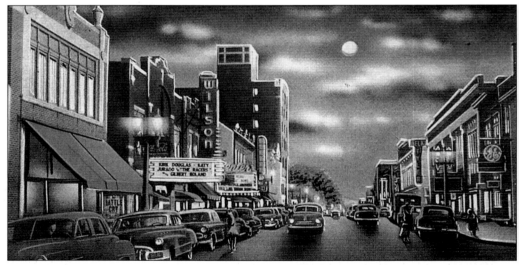

This night scene of the business district shows the Bullock Building to the left with the marquee for the Wilson Theater. The marquee says, "Kirk Douglas, Katy Jurado in *The Racers* with Gilbert Holland." This theater was the focal point for much entertainment in Wilson and recently went through a major restoration in 1998. It was built in 1919 as a vaudeville theater and seats 650 people. The G.R. Hammond Gallery is in the front lobby area of the cultural center. The Bullock sisters, Ula, Mamie, Annie, and Fannie, built the Bullock building as rental property and named it in honor of their brother, J. Dempsey Bullock (1864–1928).

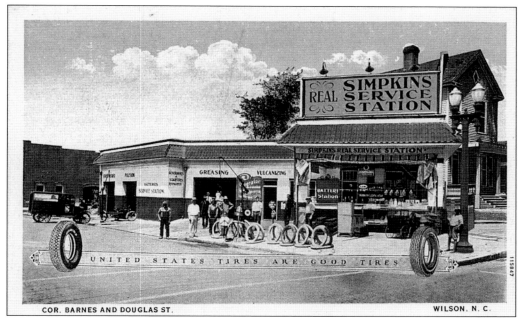

Simpkins Service Station, on the corner of Barnes and Douglas Streets, is still standing. They advertised United States Tires, Prest-O-Lite storage batteries, anti-laundry, doping, cleaning, and vulcanizing motors. They could be called at #1607. The station was built in 1930 for Arthur Ruffin and was first managed by Vance T. Forbes through the 1940s.

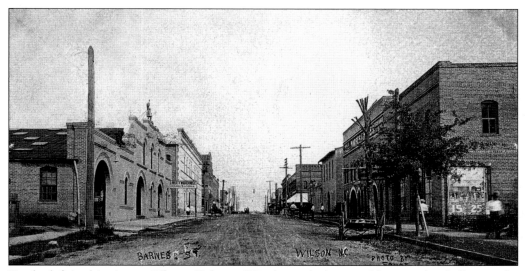

To the left in this picture, Liberty Tobacco Warehouse is shown with a wooden Indian on the top of the front facade. "Pocahontas" was acquired from a Richmond, Virginia antique store by Adolphus O. Redcap, who came to Wilson in 1899. After the 1950s, the Indian was sheltered in the office of the Centre Brick Warehouse #2. Tobacco was always important to Wilson and attracted many farmers that sold their pounds, bought goods, did courthouse business, and ate and slept. This warehouse was completed in time for the 1914 tobacco market. By 1916, it became a re-drying facility for Mr. W.T. Clark and Company.

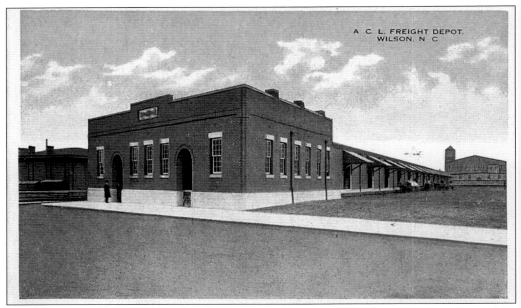

The ACL Freight Depot, built *c.* 1915, was located on Barnes Street next to the railroad. The Wilson Cotton Mill is in the background. According to the notes on the back, Morris Barker of Barker's 5-and-10 cent store bought 1,000 of these cards, as did Patterson Drug Store, for $2.50 per thousand on March 4, 1916.

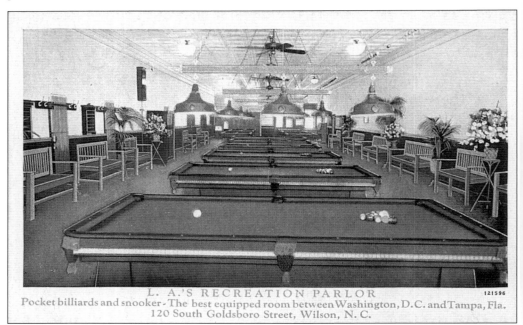

L.A.'s Recreation Parlor advertised for pocket billiards and snooker and called itself the best-equipped room between Washington, D.C. and Tampa, Florida. Note the arts and crafts benches, plant stands, pool tables, and hanging light fixtures. Located at 120 North Goldsboro Street, the pool hall was owned by Luther A. Barnes.

This 1919 postcard shows Matthews Drug Store on the northeast corner of Goldsboro and Barnes Streets. The drugstore was owned by W.R. Matthews. The building was constructed in 1916 by George, Joe, and Charles R. Saleeby. As early Lebanese families to Wilson, they built their confectionary and wholesale produce store at this location. The building later became the drugstore as well as many other businesses.

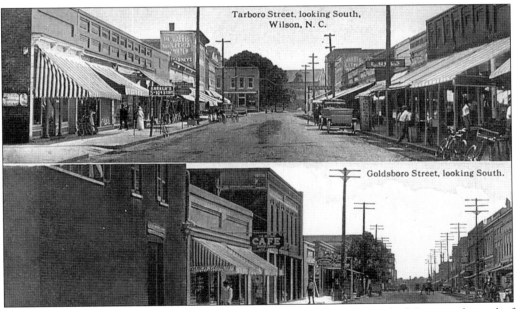

The top section shows Tarboro Street looking west with the P.L. Woodard Store at the end of the block. On the left is Barker's 5-and-10 cent store. The Barkers were Russian/Jewish merchants who arrived in Wilson in the early 1900s. Morris Barker was peddling pottery throughout the South. When his mule died, he settled in Wilson. On the bottom is a rare view of Goldsboro Street looking west. Note the awnings in both pictures.

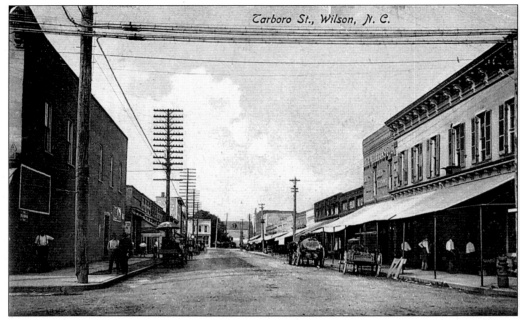

Tarboro Street is one of the older roads passing through Wilson and generally follows Highway 42, which went to Tarboro in the east and to Smithfield to the west. Many of the historic buildings in the downtown historic district are still standing. Some have had "face-lifts," including new facades.

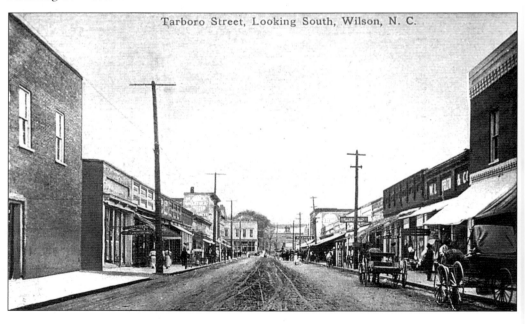

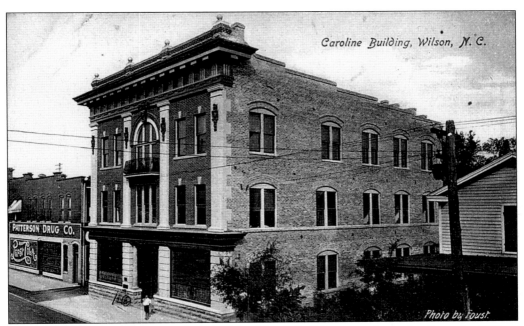

The Caroline Building, later called the Trueblood Building, was located where the Wilson County school board office is now located on Tarboro Street.

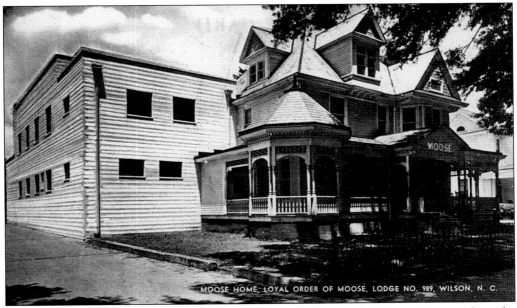

The Loyal Order of Moose, Lodge No. 989, was located on Tarboro Street near and on the same side as the Wilson County school board office. The Moose organization was founded in 1918 with J.W. Welch as the first governor. The residential home was built in the 1890s. A non-conforming addition was built sometime before this 1952 postcard was made. The home was owned by Mr. Charles M. Fleming, head of Imperial Tobacco Company.

Won't you please
write to

WILSON, N. C.

I'll be anxious to hear
from you.

Wilson has long been a regional commercial center. Efforts are now being made to bring vitality back to the downtown area with the help of the Downtown Redevelopment Corporation, Historic Properties Commission, Wilson Chamber of Commerce, and the Wilson Visitors Center and Bureau. Much has been done with underground wiring, brick pavement, trees, benches, and new historically appropriate lighting to create a pleasant streetscape.

The Business Centre of Wilson.

Wilson has recently restored the 1917 Wilson Theater and the 1923 train depot. The Cherry Hotel has been renovated into apartments, as has the Charles L. Coon School. The post office was converted into Imagination Station, a children's science museum, and the Branch Bank was made into the Arts Council. The town also developed a 150th year celebration park near the original starting point of Hickory Grove. There are five historic districts in the city.

Two
PUBLIC BUILDINGS
AND BANKS

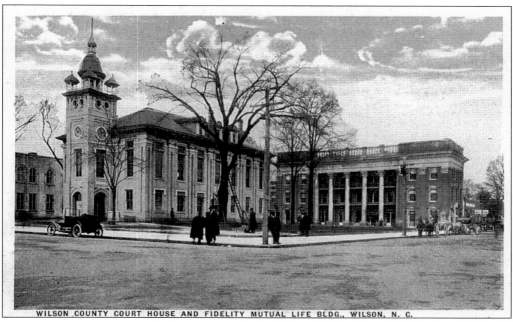

WILSON COUNTY COURT HOUSE AND FIDELITY MUTUAL LIFE BLDG., WILSON, N. C.

This 1921 postcard shows the Wilson County Courthouse with the Fidelity Mutual Building to the rear. The National Bank of Wilson is to the left. The first courthouse for Wilson was built in 1857 in the Tudor revival style. It was remodeled in 1902 with a new hipped-roof and a baroque bell tower. It was razed in 1922 for the new courthouse.

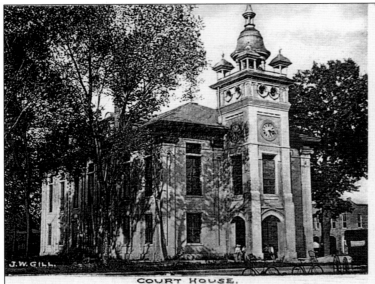

GREETINGS FROM
WILSON, N.C.

Mabel and Zelma Williams, Christmas 1906.

Christmas 1906 is the date of this view of the county courthouse by photographer J.W. Gill. The card is signed by Mabel and Zelma Williams, though nothing else is written on the back. David Connor, an Irish Catholic carpenter, was brought to Wilson for the construction of the courthouse. His family later became noted jurists and one was Archivist of the United States. There are local North Carolina historical highway markers for H.G. Connor Jr. and R.D.W. Connor.

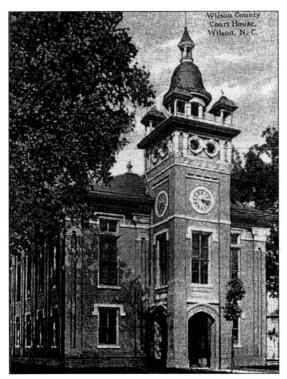

Wilson County
Court House,
Wilson, N. C.

This close-up view of the courthouse shows the detail of the tower and the clock. The courthouse has been in the same location since the county was established in 1855. When the county was formed, it was created around the town of Wilson in the geographic center. Almost half of Wilson County was created from Edgecombe County, including the town of Wilson. The rest of the county came from parts of Johnston, Nash, and Wayne (formally Dobbs and Glasgow) Counties.

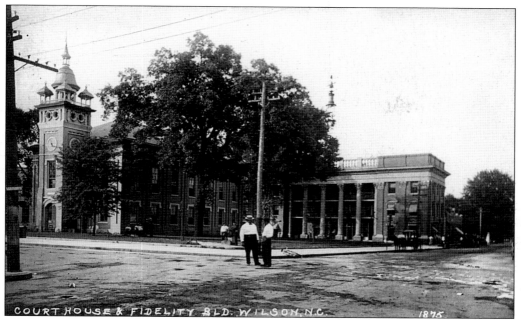

COURT HOUSE & FIDELITY BLD. WILSON, N.C. 1875

The courthouse has a public well for drinking water near the corner of Nash and Goldsboro Streets. Though there was opposition, creating a new county kept the citizens from having to go by horse, buggy, or wagon to their respective county seats to do court business in Nashville, Smithfield, Tarboro, or Goldsboro. There were many creeks and rivers to cross, some with no bridges.

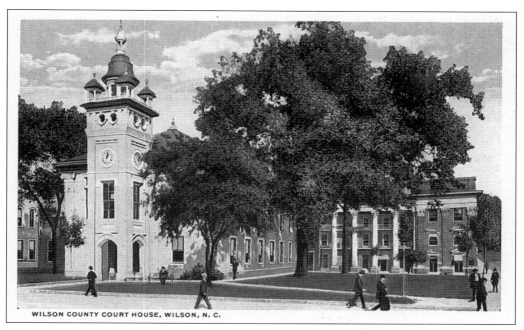

WILSON COUNTY COURT HOUSE, WILSON, N. C.

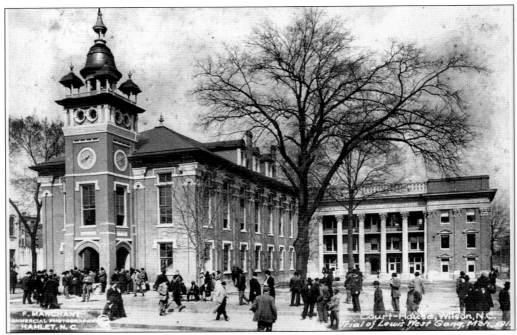

These postcards are by Frank Marchant, a Hamlet, North Carolina photographer. He took these in March 1911 at the Lewis West (1887–1911) murder trial. West was found guilty of killing Wilson County sheriff George Mumford and severely wounding O.A. Glover, the town of Wilson's police chief. The top picture shows the crowd of interested spectators during the trial. The bottom picture shows the jury made up of white male citizens of Wilson County. The names of the jury are in the Wilson County courthouse.

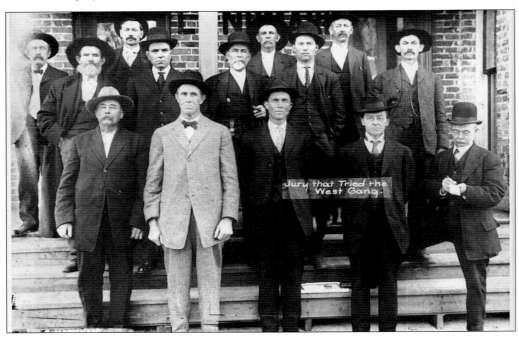

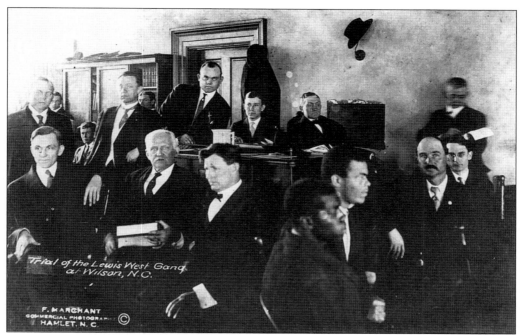

The above photograph shows the legal team at work at the Lewis West trial with Judge Joseph S. Adams (the older man). Also shown are defense attorneys W.A. Lucas (leaning over on the desk), E.J. Barnes, and solicitor R.G. Allsbrook. The two leaders of the gang are at lower right with Ed Stallings (alias "Stetson") in the front and Lewis West in the back. The bottom photograph shows the home of Mary Young, where the sheriff was killed and the chief of police was wounded.

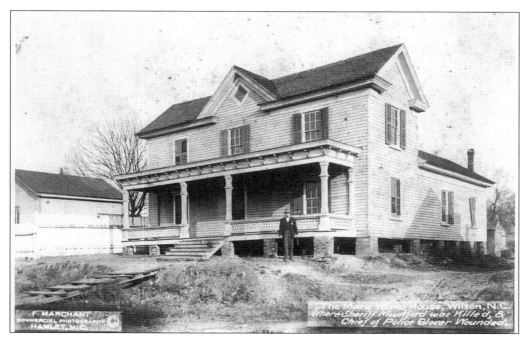

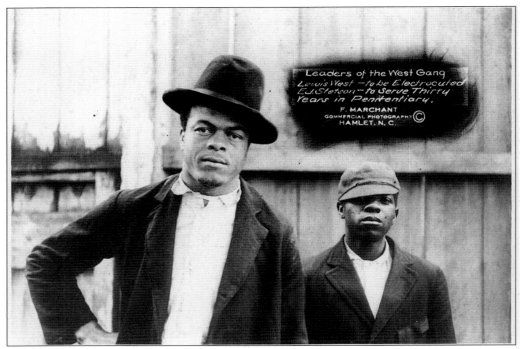

The top photograph shows Lewis West and Ed Stallings, alias "Stetson." The bottom photograph shows Sheriff W.D.P. Sharp of Wilson on the far left and his deputies in the back row. The others are members of the Lewis West gang. Lewis West was electrocuted and Ed Stallings served 30 years in the penitentiary. Steve Massengill of North Carolina Archives and History has written a book entitled *The Photographs of Frank Marchant, Commercial Photographer, Hamlet, NC 1907–1930's*. It was privately published in 1989.

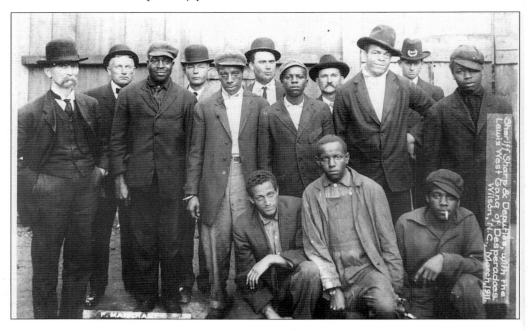

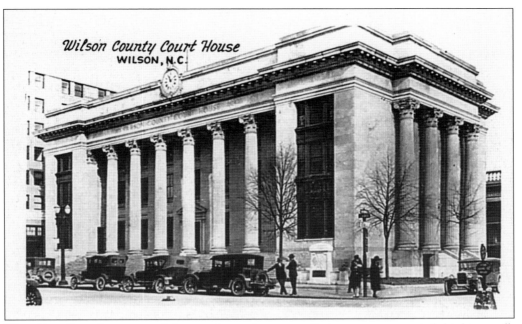

The old well on the corner of the courthouse lot eventually became a segregated drinking well, with blacks on one side and whites on the other. The drinking monument to Civil War and Revolutionary War soldiers was put up by the John Dunham Chapter of the United Daughters of the Confederacy and the Thomas Hadley Chapter of the Daughters of the American Revolution on November 11, 1926. The drinking fountain was removed in the 1960s and the markings pointing to segregation were removed. The second Wilson County courthouse was built in 1924. It was designed by Fred A. Bishop and built by William P. Rose of Goldsboro, North Carolina.

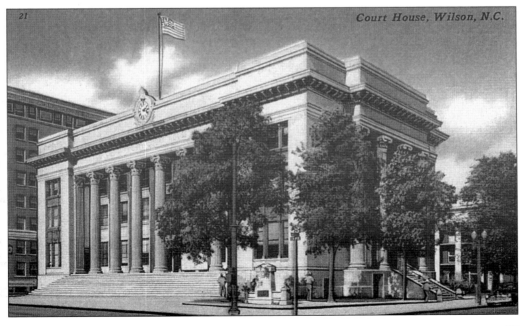

Court House, Wilson, N.C.

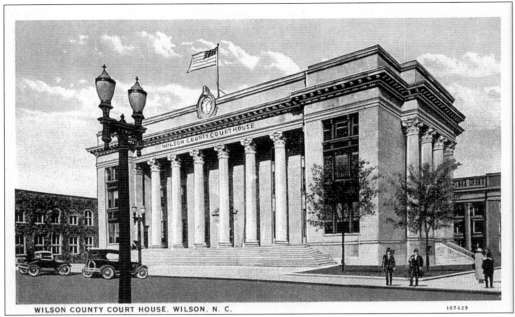

WILSON COUNTY COURT HOUSE, WILSON, N. C. 107429

This white-border card was printed by the Asheville Postcard Company in the 1920s. The National Bank of Wilson is covered in ivy and the city is sporting new streetlights. The words "1855 Wilson County Courthouse 1924" are inscribed in the frieze on the courthouse.

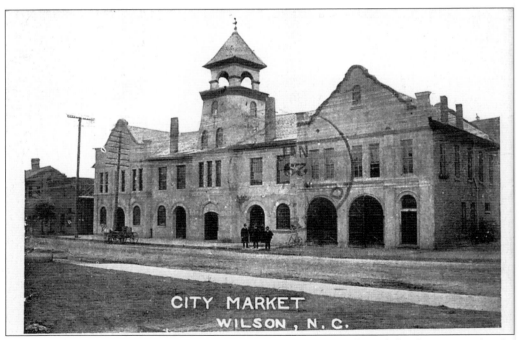

CITY MARKET
WILSON, N. C.

Postmarked in 1912, this postcard shows City Market, City Hall, and the fire station (to the right). The building burned to the ground on December 4, 1925. A small surviving section of the building was used to house town offices until a new building was constructed in 1938.

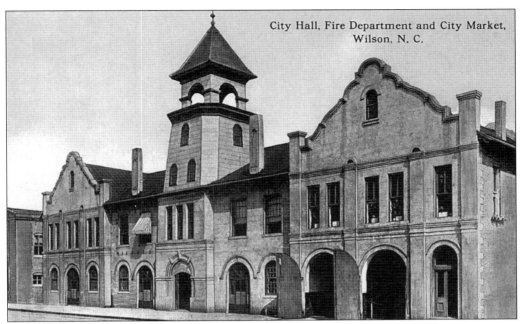

City Hall, Fire Department and City Market, Wilson, N. C.

This 1921 card shows the open doors of the fire station. It is an outstanding Spanish Mission building with a central tower for the fire bell. The building was constructed in 1906 by D.J. Rose of Rocky Mount, North Carolina.

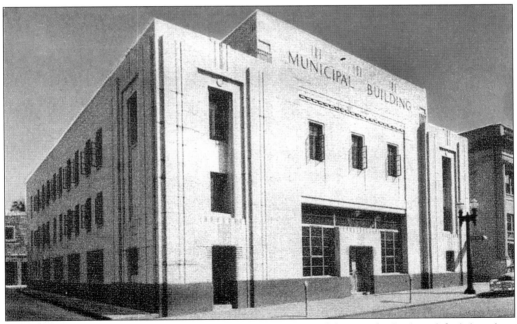

The art-deco municipal building was built in 1938 as part of the Works Project Administration. It was designed by Wilson architect Frank W. Benton (1882–1960) and built by the Jones Brothers. It is an outstanding example of art deco architecture and is one of the few examples left in Wilson. Planters Bank is on the right.

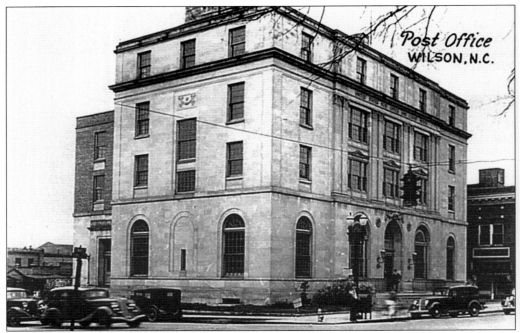

The post office and Federal courthouse was built in 1930. It continued as a post office until 1981 when a new one was built. The original building was designed by James A. Wetmore of the Treasury Department under the direction of general contractor Charles Weitz's Sons of Des Moines, Iowa. It is now serving as the home for the children's science museum, Imagination Station.

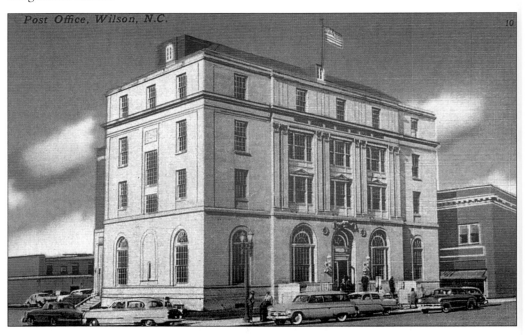

Postmarked 1932, this card shows the First National Bank of Wilson, established in 1874. Built in 1927 with eight stories, this was Wilson's tallest building until BB&T built their first tower in 1966. The First National Bank building was designed by C.C. Hartman of Greensboro and constructed by the John J. Wilson Company of Richmond, Virginia. It is now used as office space by Wilson County.

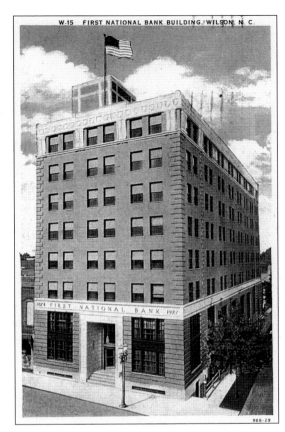

W-15 FIRST NATIONAL BANK BUILDING, WILSON, N. C.

Planter's Bank was built in 1920, probably by the Jones Brothers Construction Company. The bank was organized in 1919 with $1,500,000 in resources. William E. Smith was president, George E. Walston was cashier, and Walter C. Grant was assistant cashier. The bank failed on December 31, 1931 (one day before the First National Bank of Wilson failed) and never re-opened. The city of Wilson owns the building now.

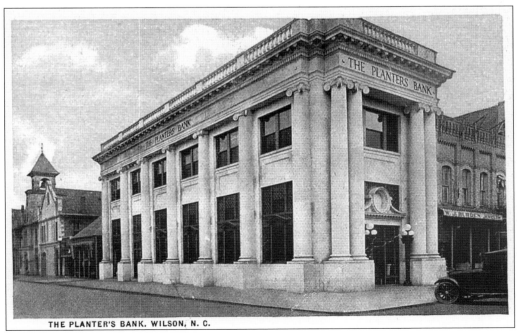

THE PLANTER'S BANK, WILSON, N. C.

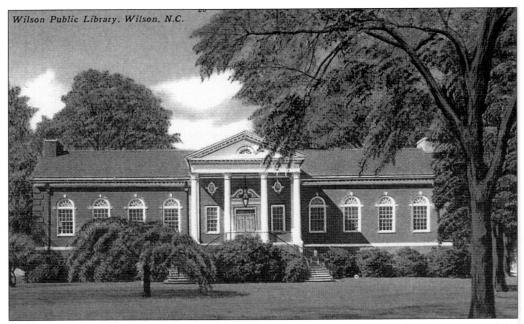

The Wilson County public library is located at 249 West Nash Street and stands as one of the architectural focal points for the city. It was designed by Frank W. Benton and built in 1939 as one of the biggest Works Progress Administration projects in Wilson County. An addition was added in 1980 and another addition will be added in 2003. Dr. Patrick Valentine is the head of the library. He wrote in 2002, *The Rise of a Southern Town, Wilson, North Carolina, 1849–1920.*

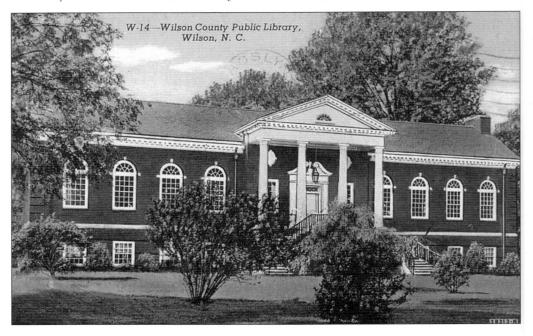

Three
HOSPITALS AND HOTELS

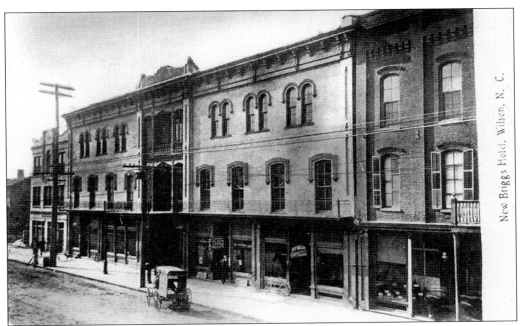

The Briggs Hotel, built in 1873, was one of the more popular hotels in Wilson. Since it was close to the train station, courthouse, and hospital, it was strategically located for the business traveler.

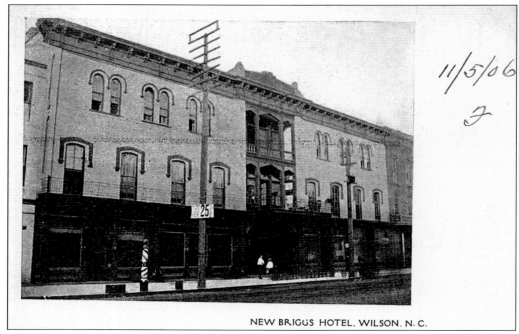

NEW BRIGGS HOTEL, WILSON, N.C.

11/5/06

This 1906 scene of Briggs Hotel shows the barber's pole along with a 25 mph speed limit sign posted on an electrical pole.

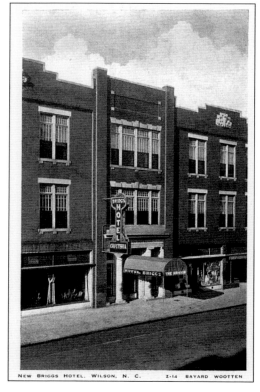

NEW BRIGGS HOTEL, WILSON, N. C. Z-14 BAYARD WOOTTEN

Noted female photographer Bayard Wootten (1875–1959) of New Bern, North Carolina took this photograph of the New Briggs Hotel. The whole front of the building was improved, including a change in all the windows, door front, and roofline. The postcard is dated March 18, 1939. The Hotel had 100 rooms, advertised as fireproofed. R. Lyndo Griffin was the proprietor. The building was razed in the late 1950s and Woolworth's five-and-ten cent store was built on the site.

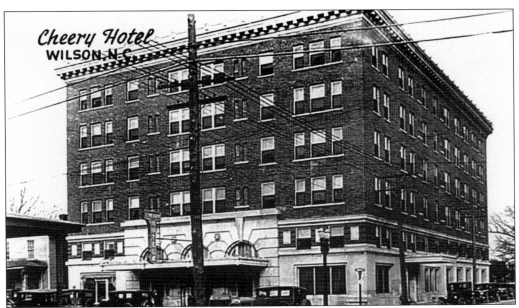

This postcard shows the Cherry Hotel misspelled, even though many patrons could have called it the "Cheery Hotel." It was named for Rufus A. Cherry, one of its builders in 1920. John T. Barnes and William N. Harrell also owned it.

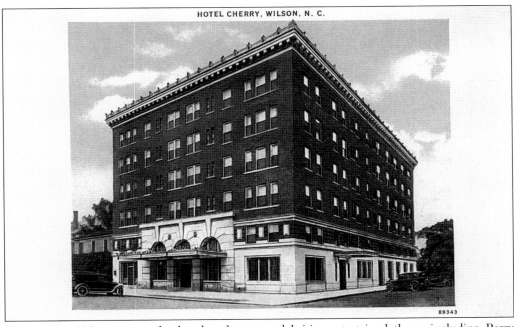

There were 200 rooms at the hotel and many celebrities entertained there, including Perry Como, Arthur Godfrey, Guy Lombardo, and the Fontaine Sisters. Many high school junior-senior proms were held in the ballroom. The hotel deteriorated and was eventually converted into apartments for the elderly.

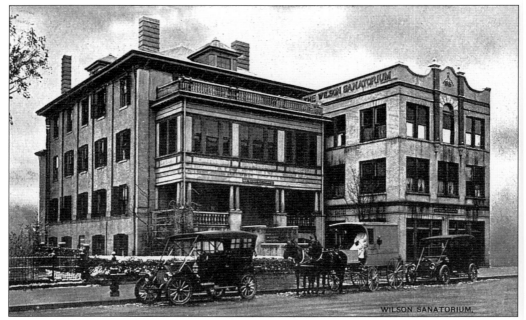

This 1913 card shows Wilson's first hospital. It was built as a private institution in 1897 by Dr. Charles E. Moore (1855–1941) and Dr. Albert Anderson (1859–1932), with Dr. Elijah Thomas Dickinson (1870–1951) joining them in 1905. Note the ambulance pulled by two horses and the snow on the ground.

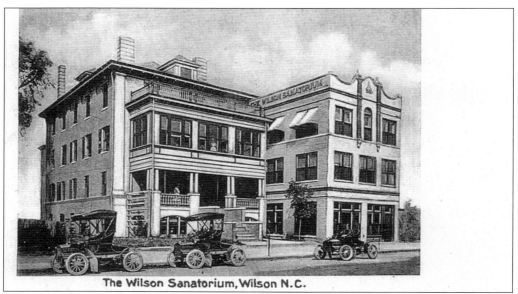

The Wilson Sanatorium, Wilson N.C.

Postmarked 1908, this card shows the original hospital to the left, which was built in 1897 and torn down in the 1920s. The Hospital Annex next door was built in 1905 and is still standing. The sign on top of the south side of the building ("Wilson Sanatorium") can still be seen from the street. This building was designed by John Christie Stout (1860–1921), a prominent Wilmington architect who worked in Wilson with Charles C. Benton from 1904 to 1906.

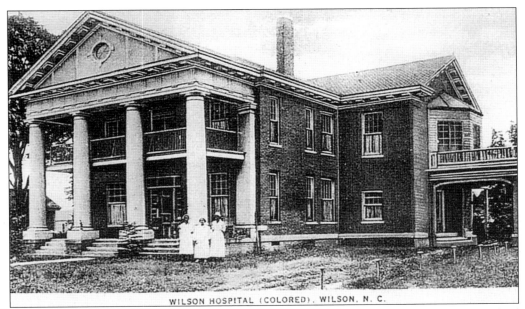

WILSON HOSPITAL (COLORED), WILSON, N. C.

This scene shows Wilson Hospital and Tubercular Home, later called Mercy Hospital. Built in 1913 and designed by Benton and Moore Architects, it was very similar in style to the Moore-Herring Hospital (which was later known as the Woodard Herring Hospital). Dr. Frank Settle Hargrave had started a private hospital *c.* 1905 in the "16-room house" on Greene Street. Samuel Hynes Vick and Prof. J.D. Reid joined Dr. Hargrave when he later established the new hospital. Dr. Hargrave was a leader in the fight against tuberculosis. He moved to New Jersey in the late 1920s and became a noted assemblyman there.

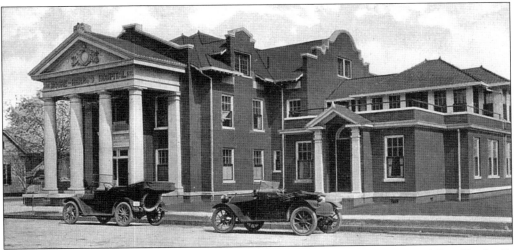

The Moore-Herring Hospital was founded by Dr. Benjamin Simms Herring and Dr. Charles E. Moore. The name was later changed to Woodard-Herring when Dr. Charles Woodard bought Dr. Moore's interest in it. The kitchen and cafeteria to the right also included a residence when it was built. Dr. Herring's son Doane became a pharmacist and in 1886 took over the pharmacy portion of his father's practice. Dr. Moore was from Nash County and moved to Wilson in 1886. In addition to the hospital, he also had extensive farming interest.

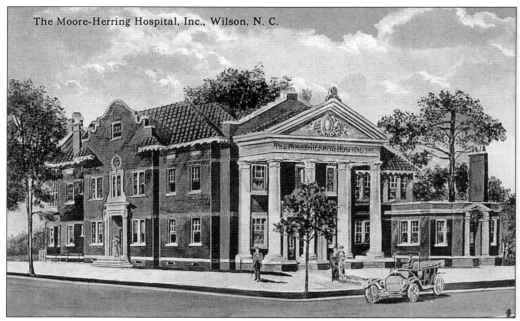

The Moore-Herring Hospital, Inc., Wilson, N. C.

The Spanish Mission–style hospital had a neo-classical front and tile roof. The Woodard–Herring Hospital was in use until the 1960s when the Wilson Memorial Hospital was built. It was then torn down and the Wilson election board relocated to the site. This postcard is postmarked January 11, 1915 and the message reads "Dear Ida, This sure is a cold morning. Looks as if we might get snow. Glad to get your card. Mr. Wash Lamm is very low. He is past hope, they say. Hope you all are well. All here are up. Mary."

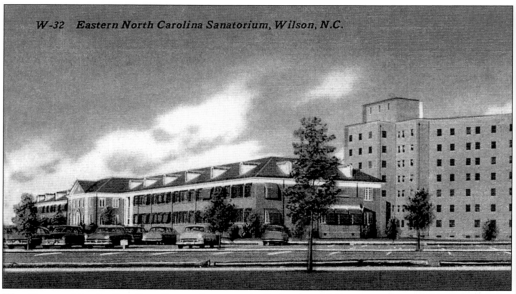

W-32 Eastern North Carolina Sanatorium, Wilson, N.C.

The Eastern North Carolina Sanatorium was built in the 1950s to combat tuberculosis in the eastern part of the state. An equivalent building was built in western North Carolina. The hospital is still in use but now has a different mission. This linen postcard was produced in the 1950s.

Four
SCHOOLS AND
CHURCHES

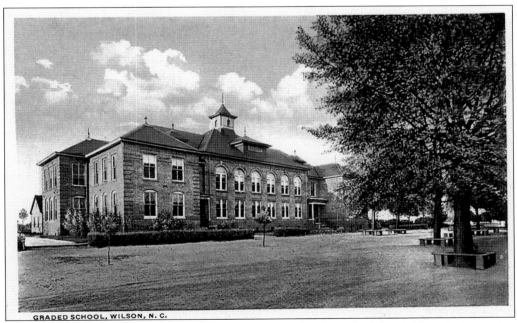

GRADED SCHOOL, WILSON, N. C.

The Wilson Graded School was built in 1892 but only allowed white children in its grades. The school was later renamed in the 1920s to honor an early educator, Margaret Hearne (1852–1949). When the Wilson High School was built in 1923, it was later named Charles L. Coon High School.

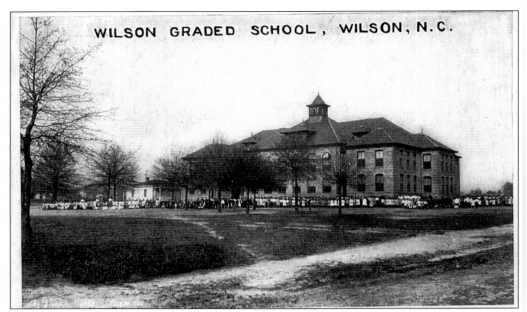

WILSON GRADED SCHOOL, WILSON, N.C.

Margaret Hearne School was built in 1892 and was a longtime school building in Wilson. It was torn down in the 1980s and replaced with the current Margaret Hearne School at the same location and currently used as an elementary school.

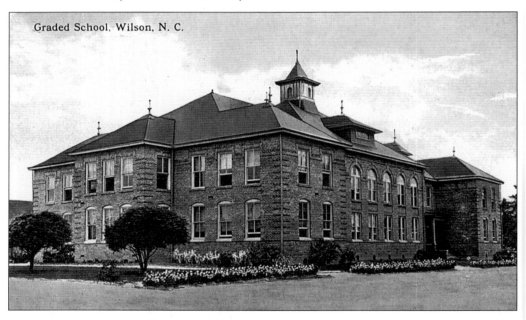

Graded School, Wilson, N. C.

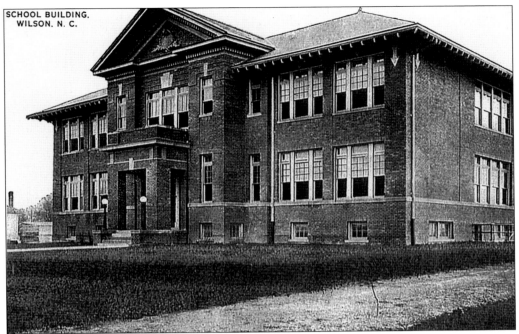

SCHOOL BUILDING.
WILSON, N. C.

Woodard School was the first elementary school in Wilson built in a residential neighborhood. Named for Congressman Frederick A. Woodard, the only local Congressman ever elected from Wilson, the school was located on Kenan Street at the corner of ACC Boulevard. It was built in 1914 with 16 classrooms; a rear section was added in 1928. It was torn down in the 1980s.

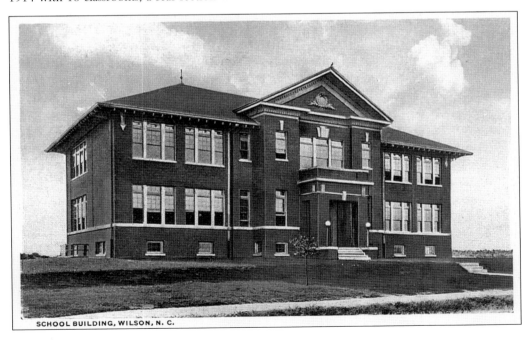

SCHOOL BUILDING, WILSON, N. C.

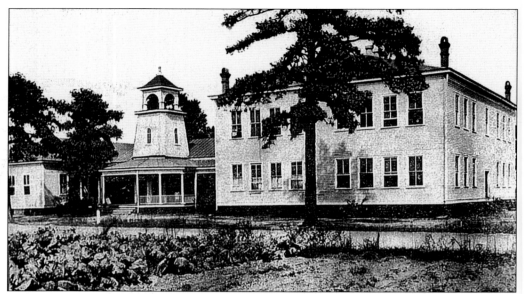

The Wilson Colored Graded School on Stantonsburg Road was later named for Sallie Barbour, a respected early teacher. The wooden school was architecturally attractive. Note the collard patch across from the school. Prof. J.D. Reid was principal for many years and along with Charles L. Coon, the superintendent, they worked hard to make Wilson County a leader in North Carolina public schools.

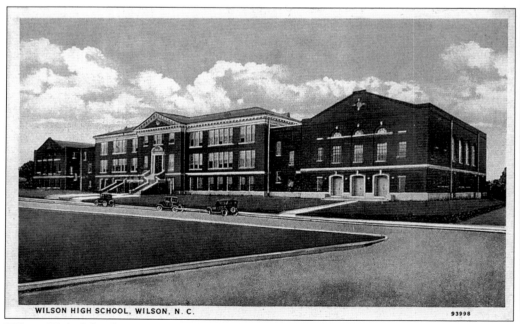

WILSON HIGH SCHOOL, WILSON, N. C. 93998

Wilson High School was later named for Charles L. Coon (1868–1927), a long-term city and county superintendent. Wilson was known throughout the 1920s and 1930s as having the most progressive school system in the state. A North Carolina state historical highway marker stands on Vance Street near his house honoring him.

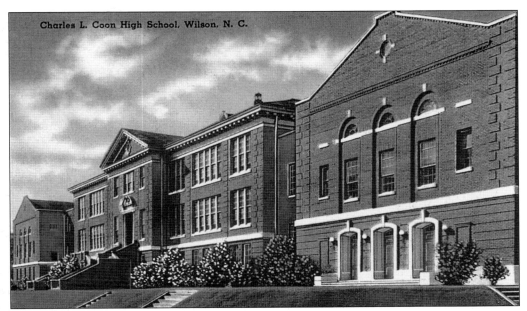

Charles L. Coon High School was a leader in the state academically and athletically. The gym was to the left. The school also boasted an indoor swimming pool, one of the first for a North Carolina public school. To the far right was the auditorium that hosted many community events and entertainment. Elvis Presley even sang there in 1957. The lunchroom was in the basement behind the entrance steps. Note the water tower to the left in the bottom postcard.

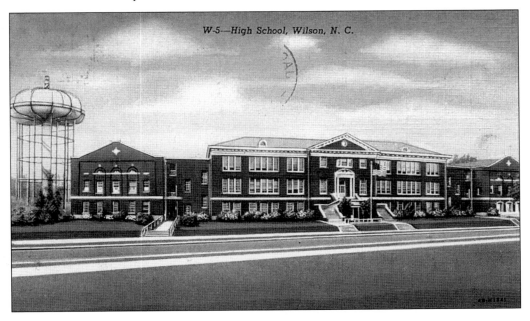

W-5—High School, Wilson, N. C.

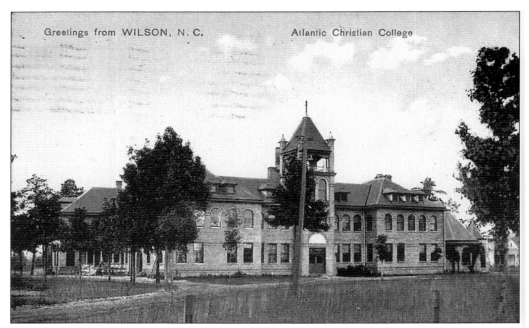

Greetings from WILSON, N. C. Atlantic Christian College

Atlantic Christian College was founded in 1902 by the Disciples of Christ (Christian) Church. The postcard shows Kinsey Hall, which contained the dormitory rooms and classrooms for the college. The top card is postmarked 1908.

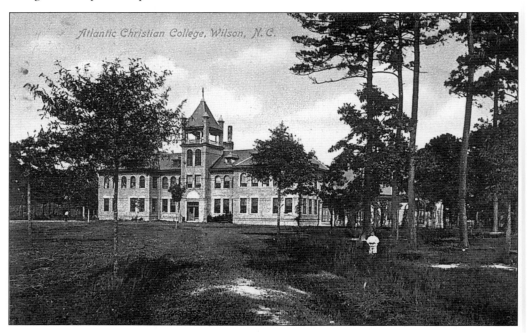

Atlantic Christian College, Wilson, N. C.

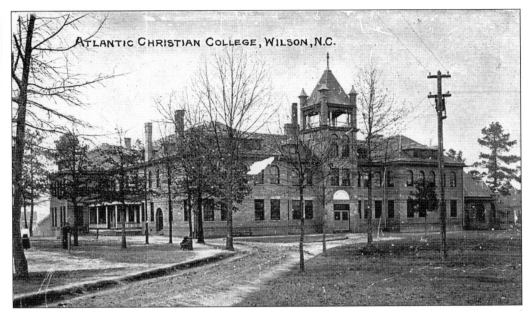

ATLANTIC CHRISTIAN COLLEGE, WILSON, N.C.

The college's first president was James C. Coggins from 1902 to 1904. John J. Harper then served from 1904 to 1908, followed by Jesse C. Caldwell from 1908 to 1916. The college changed its name in the 1980s to Barton College, in honor of an early Disciple's leader named Barton W. Stone. The bottom card is dated 1908.

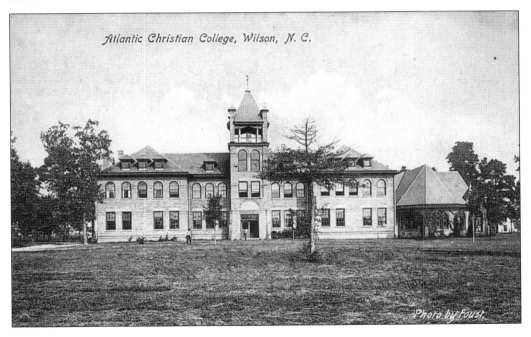

Atlantic Christian College, Wilson, N. C.

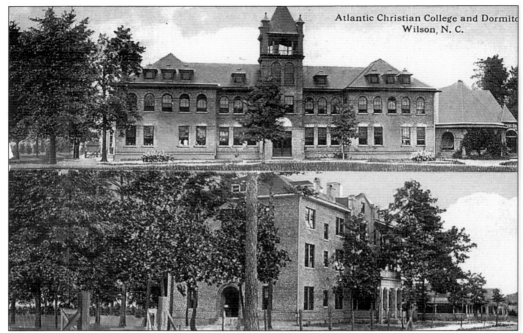

Atlantic Christian College and Dormito
Wilson, N. C.

The double card at the top, postmarked 1914, shows Kinsey Hall and the boys' dormitory on the bottom. The latter was built in the 1920s and torn down in the 1980s.

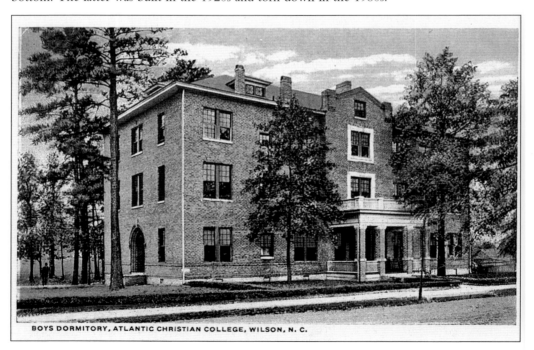

BOYS DORMITORY, ATLANTIC CHRISTIAN COLLEGE, WILSON, N. C.

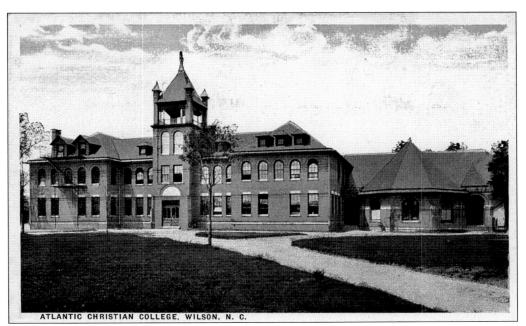

ATLANTIC CHRISTIAN COLLEGE, WILSON, N. C.

The bottom card shows the girls' dormitory, which was behind the boys' dormitory. To the left is the gymnasium. All of these buildings were torn down for expansion. Dr. W. Jerry MacLean, a history professor at the college, wrote a history of the college entitled *Barton College, Our Century* in 2002 in recognition of the school's 100th anniversary.

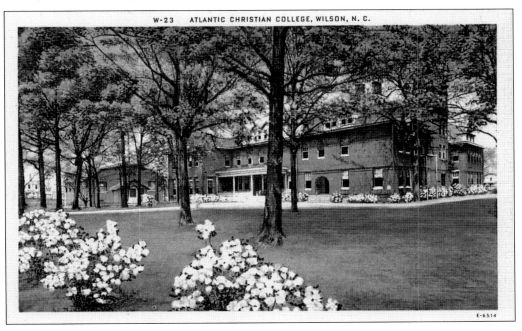

W-23 ATLANTIC CHRISTIAN COLLEGE, WILSON, N. C.

E-6514

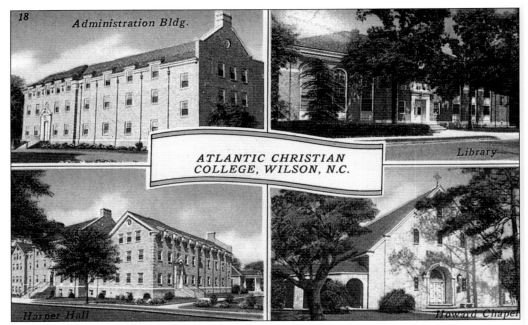

ATLANTIC CHRISTIAN COLLEGE, WILSON, N.C.

The four scenes in the above postcard show Harper Hall at the top and bottom left. To the top right is the library and to the bottom right is Howard Chapel. Excepting the chapel, the uses of all these buildings have changed. The bottom postcard shows Howard Chapel, which was the gathering place for meetings, worship service, plays, and classes.

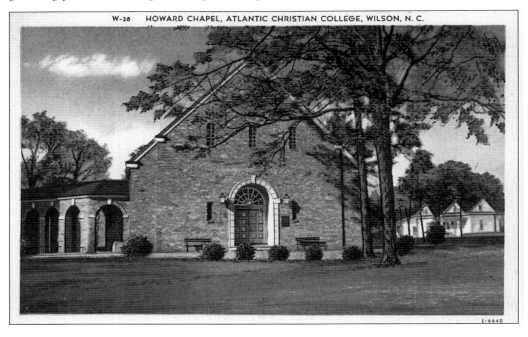

The First Presbyterian Church was located on the corner of Nash and Jackson Streets, across from the present location of the Wilson County public library. The church was built in 1885. Selecta Morse is the first known Presbyterian to reside in the city in 1853. The first services were in 1854 by an evangelist preacher from Goldsboro, Rev. Daniel T. Towles.

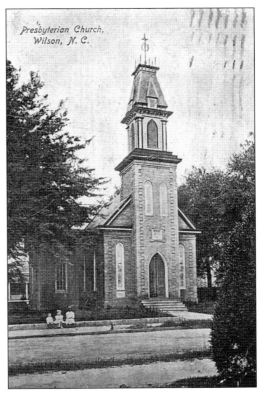

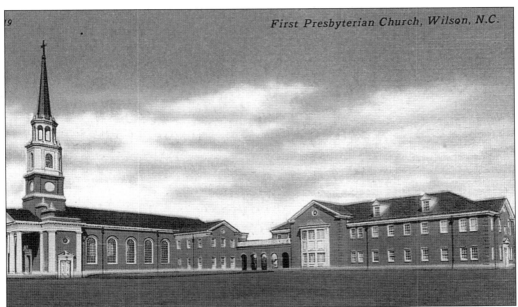

The present Presbyterian Church was built in 1950. The current pastor is Rev. James H. McKinnon, who has been there since 1980. It is located on Sunset Drive near the Wilson recreation center and park.

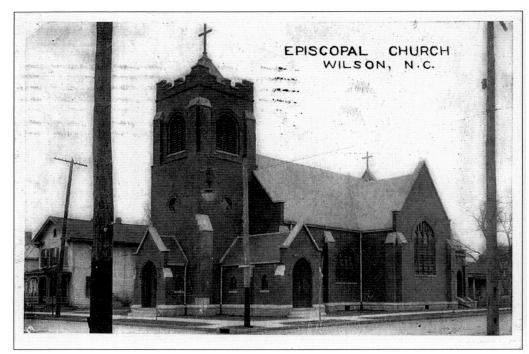

St. Timothy's Episcopal Church was founded in 1856 and located on the corner of Goldsboro and Green Streets. The wooden Gothic-style church was moved behind the church lot when the current 1906 church was built.

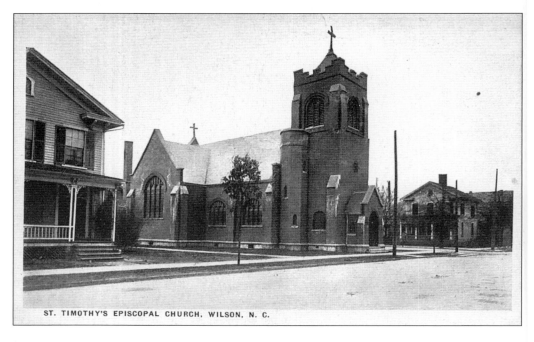

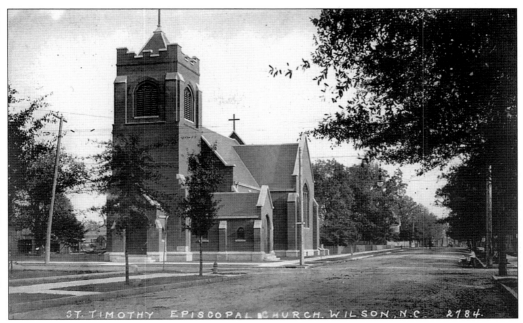

ST. TIMOTHY EPISCOPAL CHURCH, WILSON, N.C. 2784.

The rare bottom photograph shows the interior of St. Timothy's Episcopal Church ready for the Easter service in 1914. Wooden panels were added to the altar in the 1940s.

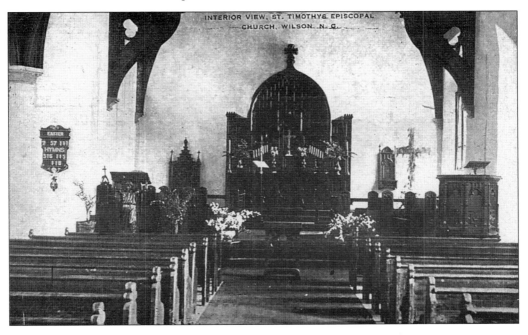

INTERIOR VIEW, ST. TIMOTHYS EPISCOPAL
CHURCH, WILSON, N.C.

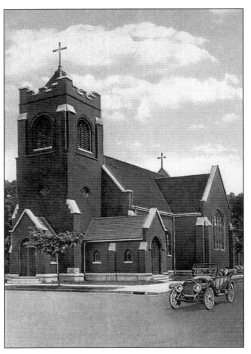

Thomas Crowder Davis was a longtime leader at St. Timothy's, having served as Senior Warden from 1860 to 1915. William J. Boykin was Senior Warden from 1915 to 1937. The Rev. Chris Hardman is the current minister.

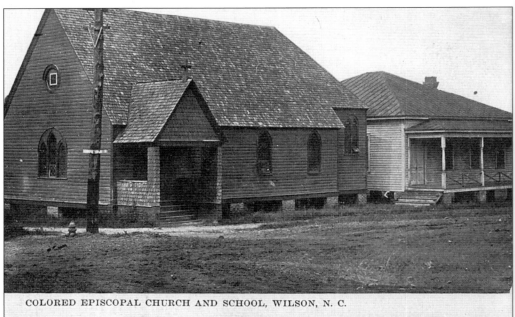

COLORED EPISCOPAL CHURCH AND SCHOOL, WILSON, N. C.

St. Mark's Episcopal Church was founded in 1887 by John H. Clark, a Wilson postal employee. It is one of the oldest black Episcopal churches in North Carolina. A parochial school seen at the back of the church was established in 1891 and was open through the 1920s. This building was located on the northwest corner of Lodge and South Streets. The current church is on the corner of Reid and East Nash Streets.

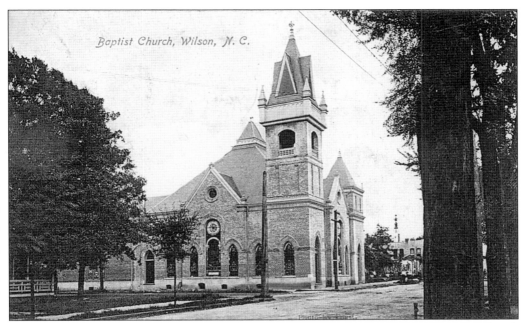

Baptist Church, Wilson, N. C.

Postmarked in 1908, the top postcard shows the First Baptist Church built in 1905. The church was founded in 1860 and located on the corner of Lodge and Green Streets. Members worshipped in this location until 1952 when the current church was built. The current minister is the Rev. William Murray.

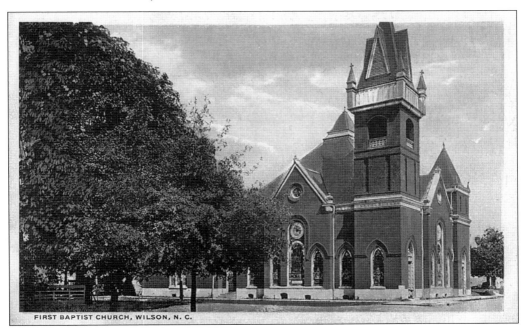

FIRST BAPTIST CHURCH, WILSON, N. C.

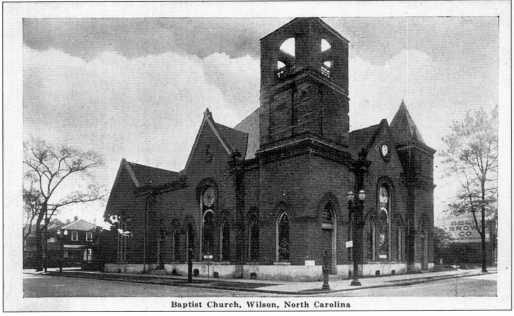

Baptist Church, Wilson, North Carolina

The Graycraft card company card shows the First Baptist Church after Hurricane Hazel in 1954. Note the damage to the tower. First Citizens Bank is now located where the church once stood.

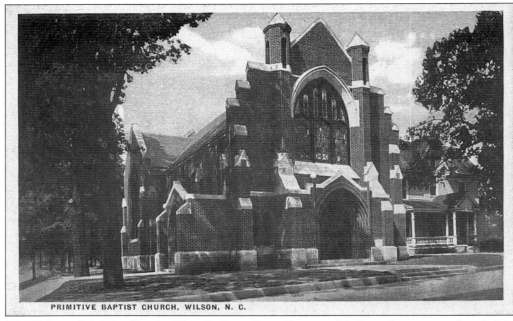

PRIMITIVE BAPTIST CHURCH, WILSON, N. C.

The Toisnot Primitive Baptist Church, located on Green and Jackson Streets, was founded in 1756 by Jonathan Thomas (1735–1775). It is the oldest congregation in the area. In 1805, the congregation moved to the downtown area and in 1920, the church shown here was built. Charles C. Benton, a local Episcopalian, was the architect. The congregation no longer exists.

Jackson Chapel Baptist Church was established in 1867. This building was constructed in 1913; an educational addition was completed in 2002. The building is a Wilson Historic Property.

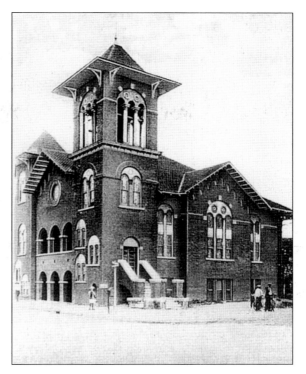

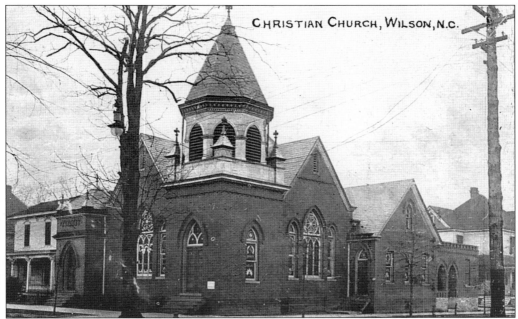

Postmarked 1911, this postcard shows the First Christian Church on the corner of Goldsboro and Vance Streets. The congregation was founded in 1871 when Dr. Frank W. Dixon held a 47-day revival in Wilson. He baptized Willis Napoleon Hackney and Robert J. Taylor, who became the first deacons of the church.

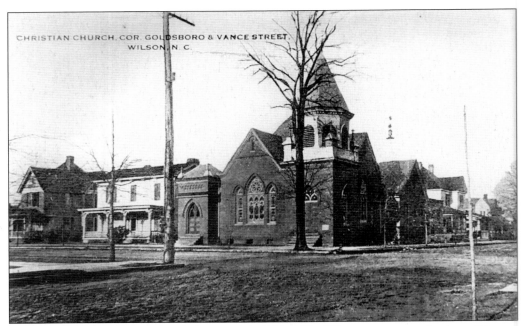

The back of the bottom card reads, "Dear Little Wife Sallie, When are you coming home? I want to see you so bad. I liked to freeze last night. You ought to be here to help eat the rabbits. Mr. Webb killed 14. Henry is married. Bye, C.O.T." This card is dated 1912.

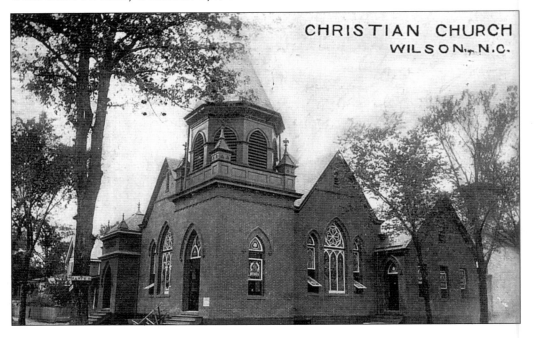

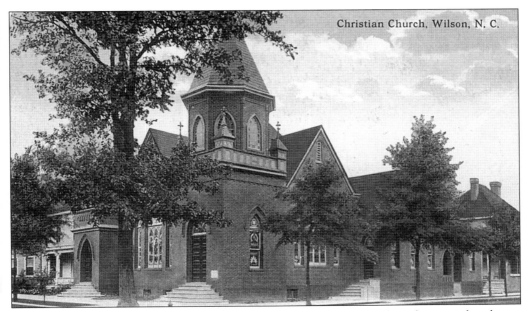

Christian Church, Wilson, N. C.

The First Christian Church stayed in this location until the 1950s, when the new church was built on the corner of Tarboro and Vance Streets.

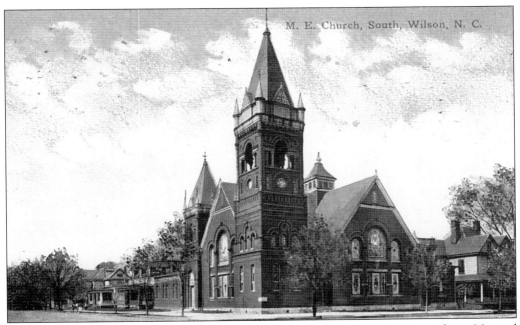

M. E. Church, South, Wilson, N. C.

The First Methodist Church was organized in 1853 with the following 17 members: Mr. and Mrs. W.D. Rountree, Mr. and Mrs. Gray Ellis, Mrs. Zilphia Manning, James Rountree, Col. John Farmer, Mrs. Jonathan Rountree, Mr. and Mrs. Edward Eatman, Mrs. Elizabeth Rountree, Mr. and Mrs. Willie Daniel, Mrs. Theresa Barnes, Mrs. M.H. Upchurch, and Mr. and Mrs. Nathan Rountree.

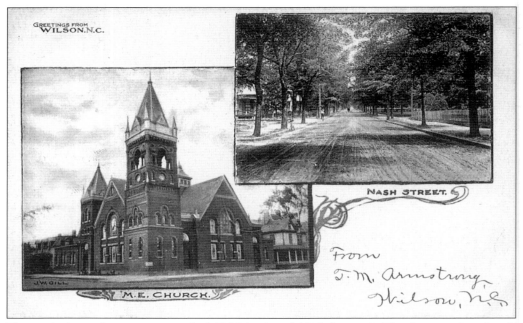

The cards shown here are postmarked 1906 (top) and 1909 (bottom). The first wooden church was built in 1854 with the Rev. Alexander Gattis as pastor. The building was constructed on a 46-by-96 foot lot in the area that is now the Green Street Courtyard. A second wooden church was built in 1875 on the present Narron and Holdford Attorneys parking lot facing Tarboro Street. It became the Opera House after the third brick church was built in 1904. The bottom card shows the wooden church behind the tree.

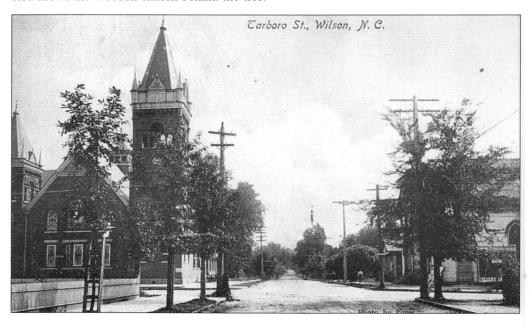

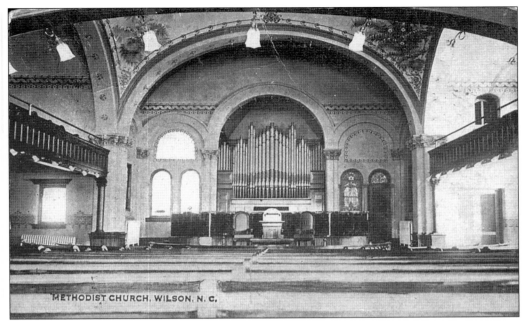

METHODIST CHURCH, WILSON, N. C.

This rare view of the interior of the First Methodist Church shows a painted ceiling with ferns and stenciled cartouches as decorative borders. The top card was postmarked 1910 and printed by O.V. Foust, a local photographer. The bottom card was printed by Louis Kaufman & Sons of Baltimore, Maryland, for Morris Barker of Barker's 5-and-10 cent store in Wilson.

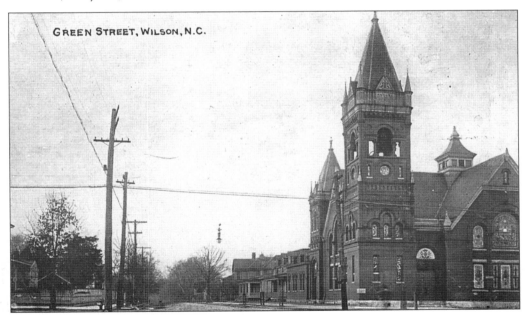

GREEN STREET, WILSON, N.C.

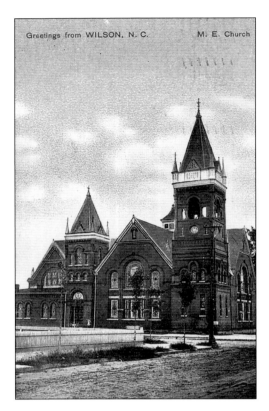

Greetings from WILSON, N. C. M. E. Church

This card, with a 1907 postmark, is of the First Methodist Church. It was made by local photographer J.W. Gill and published in Germany. This church burned in the early 1980s and a new church was rebuilt on the site. Dr. William Presnell is the current minister.

St. John African Methodist Episcopal Zion Church was organized in 1868, two years after the Civil War. The present church was built in 1916 and is now listed as a Wilson Historic Property. The church has a beautiful interior. Located in the front of the church is a North Carolina State Highway historic marker for the Rev. Owen W.L. Smith, Minister to Liberia and an early minister at the church.

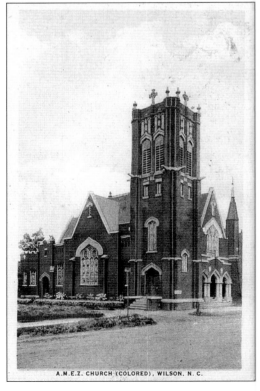

A.M.E.Z. CHURCH (COLORED), WILSON, N. C.

Five

RESIDENTIAL AREAS

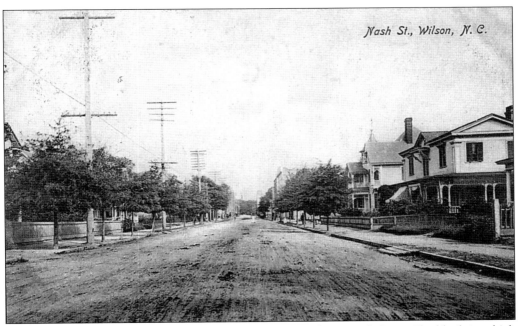

Postmarked 1909, this postcard shows the residential area of East Nash Street (the block in which the Cherry Hotel is located), looking towards the courthouse area. The furthest house on the right is the W.N. Hackney Home.

The house on the left, probably owned by Herbert Ward, is where the present Imagination Station is located. The next two buildings are the Wilson Sanatorium and the Briggs Hotel.

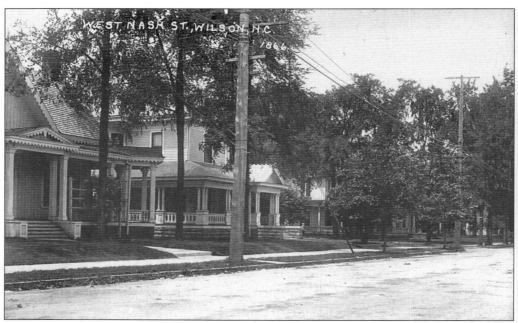

This is the southwest corner of Nash and Pine Streets. The house on the right is the Thomas Washington home; he was a noted planter and state senator from Wilson. The house on the left is the Wiggins home (parents of Ann Wiggins, John L. "Jack" Wiggins Jr, William A. Wiggins, and Lucy Wiggins Hackney). This location is currently across the street from First Citizens Bank. The homes were razed in the 1950s for commercial buildings.

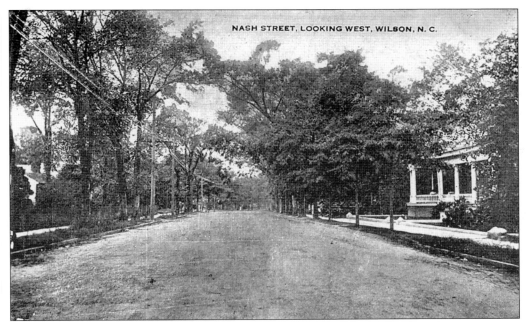

NASH STREET, LOOKING WEST, WILSON, N. C.

This is a scene in front of the Capt. Theodore Tilghman home, across from the BB&T twin towers. The photograph was by O.V. Foust of Wilson.

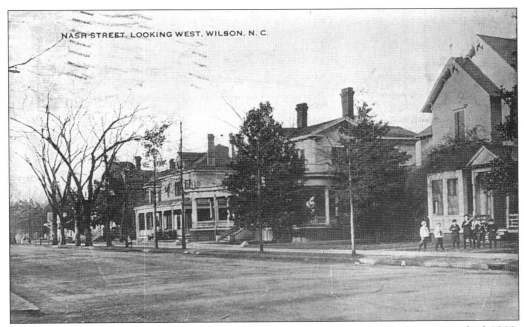

NASH STREET, LOOKING WEST, WILSON, N. C.

This is the residential block in front of the BB&T Twin Towers. The card is postmarked 1910. Notice the boys playing on the right. Lawrence Brett's house is the fourth house down on the right and is the only one still standing. The photographer is standing in the intersection of Nash and Pine Streets.

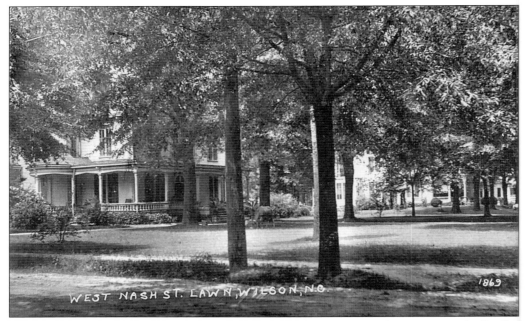

The Barnes–Bruton house is shown in this card, postmarked in 1913. The message reads, "Hello! You should have been here to see us put it on ACC (Atlantic Christian College). We beat them one to nothing. You know I had something to do with it. Best wishes, KGW."

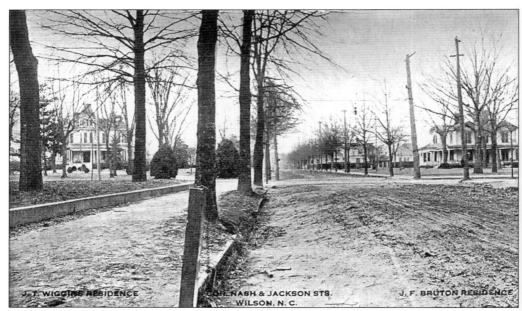

Postmarked 1910, this card shows the J.T. Wiggins home to the left and the J.F. Bruton residence to the right. O.V. Foust was standing on Jackson Street when he photographed these two Nash Street homes. The Wilson County public library was built on the site of the J.T. Wiggins home. John F. Bruton was a banker and a leader in the establishment of the Federal Reserve banking system.

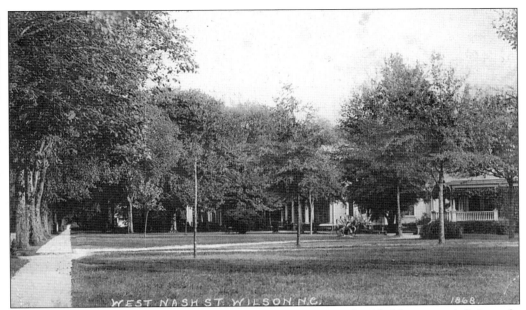

This West Nash Street scene (postmarked 1912) shows two unidentified houses and their yards. From this, one can imagine the streetscape of Wilson's main street.

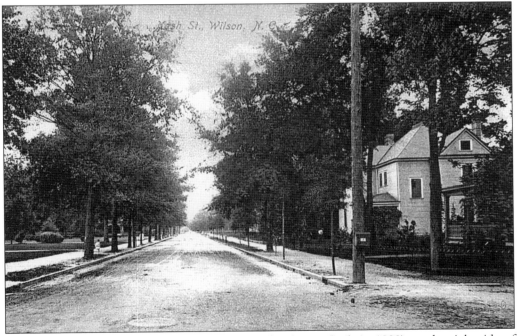

This card, postmarked 1908, shows the J.R. Boykin home (built in 1889) on the right side of Nash Street. Haywood Edmundson of Greene County, an early leader in the tobacco industry, bought the house in 1910 from Boykin. Steve L. Beaman, a native of Greene County, currently has his law firm there. The house is listed as a Wilson historic property.

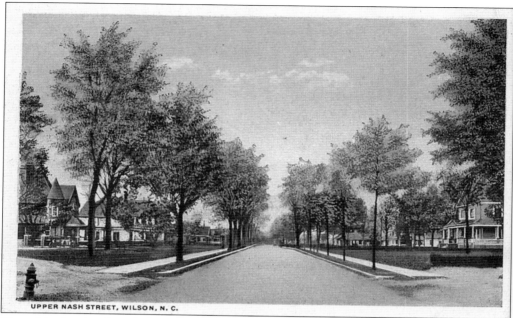

UPPER NASH STREET, WILSON, N. C.

The white-bordered card above shows upper Nash Street with its stately Victorian homes and smaller, younger trees. The bottom card is a closer view of the house on the left. Nash Street was a beautiful street for many years; there was a decline in the area after Hurricane Hazel in 1954. Many trees and homes were damaged and destroyed in that storm.

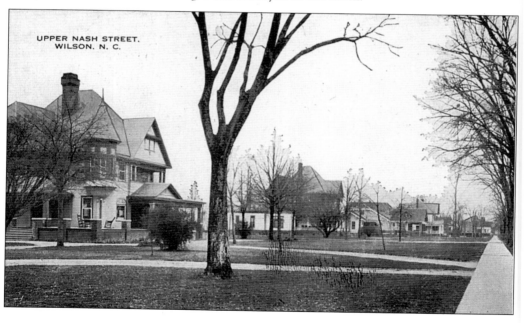

UPPER NASH STREET.
WILSON. N. C.

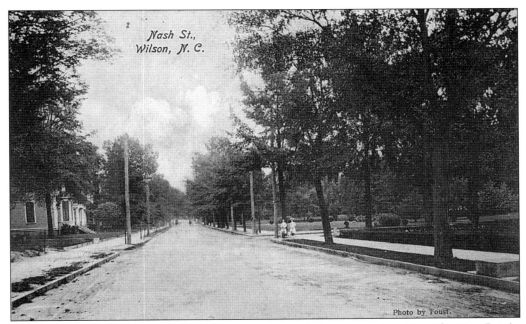

Shown here is Nash Street, where it intersects with Park Avenue to the right. The First Baptist Church is currently on the right. Note the stone block to the far bottom right, which was to assist ladies into their horse-drawn carriages or early automobiles.

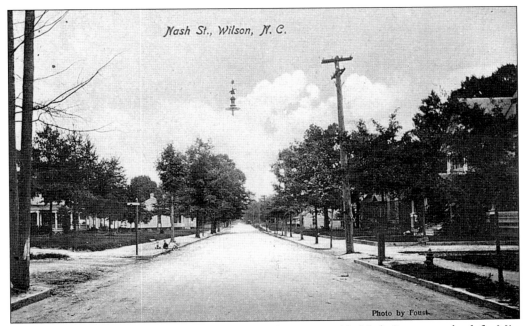

This postcard shows where Whitehead Avenue intersects with Nash Street on the left. Miss Bettie's Bed and Breakfast is currently on the corner to the left.

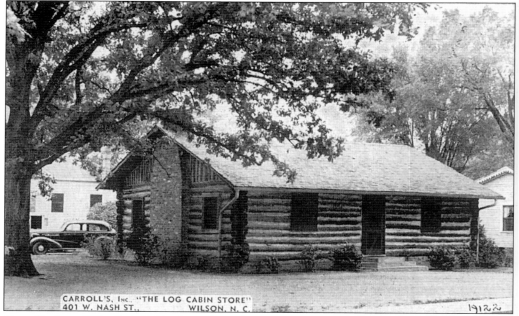

CARROLL'S, Inc., "THE LOG CABIN STORE"
401 W. NASH ST., WILSON, N. C.

Carroll's, Inc., "The Log Cabin Store," was located on the corner where the Walston Center is now. The cabin was built in 1929 for a Boy Scout troop sponsored by the First Baptist Church. Howard J. Price was president and manager of "The Log Cabin" in 1953. Many a teenager went there after school. They sold drinks, snacks, and certain foods—probably an early version of a quick-stop market.

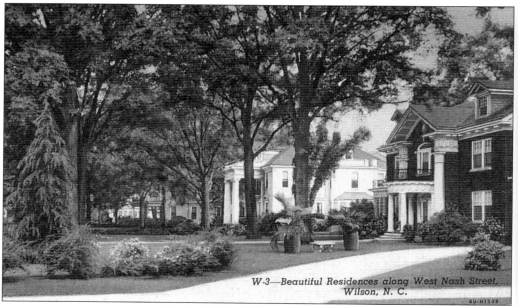

W-3—Beautiful Residences along West Nash Street,
Wilson, N. C.

This linen postcard shows the W.J. Davis home on the right and the J.C. Eagles home on the left. They are two of the many beautiful homes that lined Nash Street. J.C. Eagles was a long-term legislator from Wilson.

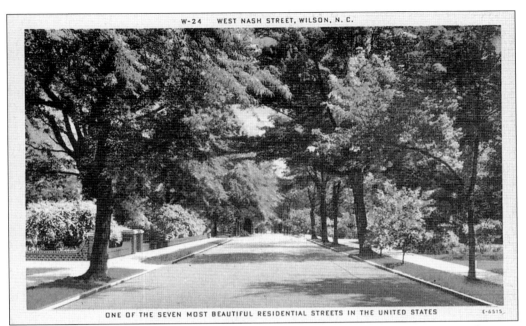

ONE OF THE SEVEN MOST BEAUTIFUL RESIDENTIAL STREETS IN THE UNITED STATES E-6515

The brick fence is around the Graves home, which is now home to the president of Barton College. It has been claimed numerous times that during the 1930s a national magazine (most likely *National Geographic*) stated that Nash Street was "One of the seven most beautiful residential streets in the United States." However, the magazine article cannot be substantiated. The claim was probably made in some early travel brochures by the Wilson Chamber of Commerce.

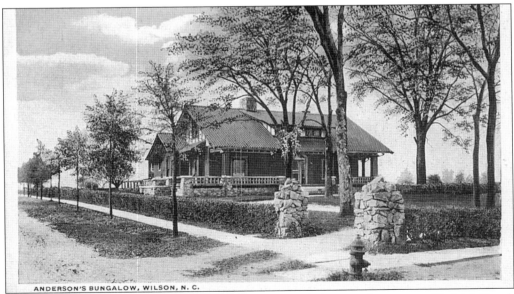

ANDERSON'S BUNGALOW, WILSON, N. C.

Built in 1917, Anderson's Bungalow, still standing on Nash Street at the corner of Raleigh Road, was one of the earliest bungalow houses in Wilson. Noted stonemason Nestus Freeman did the stone fence, columns, and foundation. The owner of the house, Selby H. Anderson (1874–1962), was Branch Bank's chairman of the board from 1915 to 1962.

77

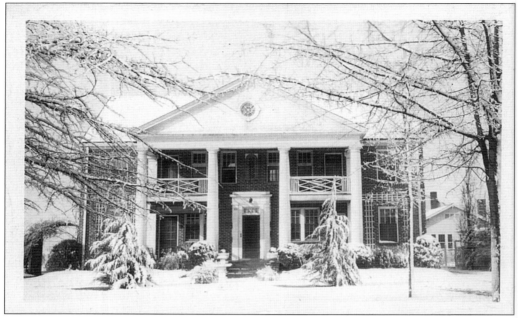

This building at 1209 West Nash Street was built by Dr. Mallory A. Pittman and Dr. G. Erick Bell in 1928 as a rental property with four apartments. Dr. Pittman and Dr. Bell were longtime physicians in Wilson and both had sons that practiced here.

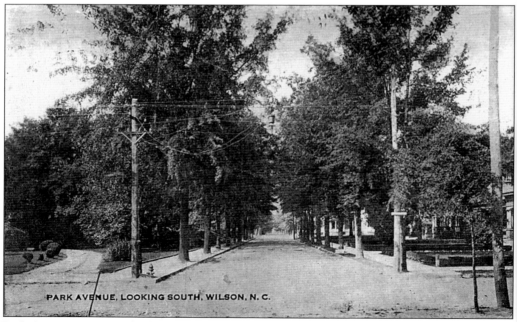

PARK AVENUE, LOOKING SOUTH, WILSON, N. C.

Park Avenue was named when the city intended to build a large park in the area. The park was never developed but the name carried on. This scene was taken standing on Nash Street. The Silas R. Lucas home, now the location of the First Baptist Church, is to the right.

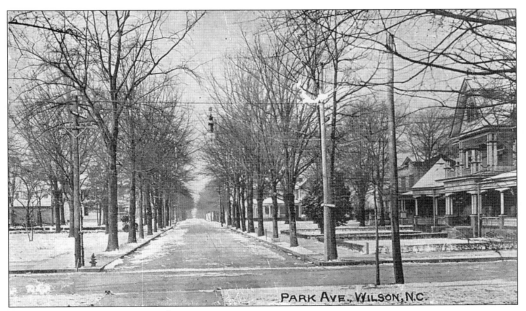

PARK AVE., WILSON, N.C.

The Silas R. Lucas House is shown on the right at the corner of Park Avenue and Nash Streets. The card is postmarked 1916.

This is a side scene of the Lucas Home from Nash Street. The house faces Park Avenue. The First Baptist Church currently occupies the property. Park Avenue was a fashionable area of Wilson to live in and many of the homes are still standing in this West Broad Street Historic District.

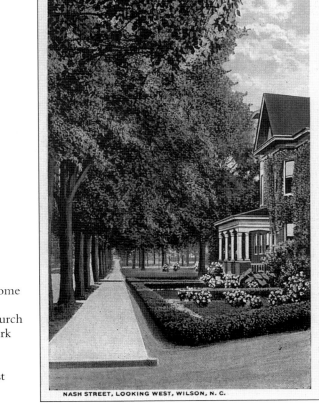

NASH STREET, LOOKING WEST, WILSON, N. C.

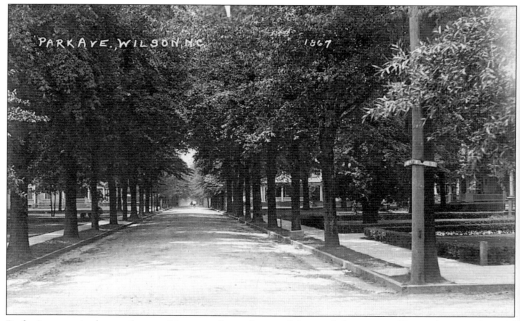

Park Avenue is shown here with a number of trees. Many of them are still standing in this old and once very fashionable neighborhood. The top and bottom photos show the dirt street with the new curbing and guttering.

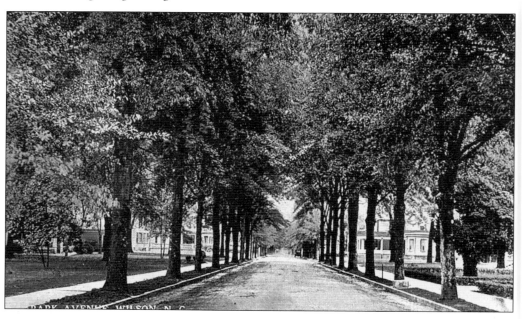

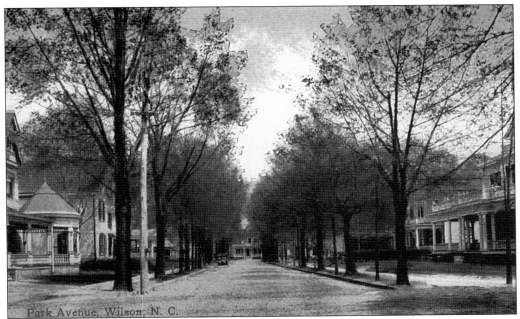

Park Avenue, Wilson, N. C.

Standing on Kenan Street and looking down Park Avenue to Nash Street, this postcard, postmarked 1915, shows the Dr. L.J. Herring Home on the left and the Roscoe Briggs Home on the right. The Herring Home was torn down by the First Baptist Church to make room for parking; the Briggs home is still standing as apartments. Herring was a longtime veterinarian in Wilson.

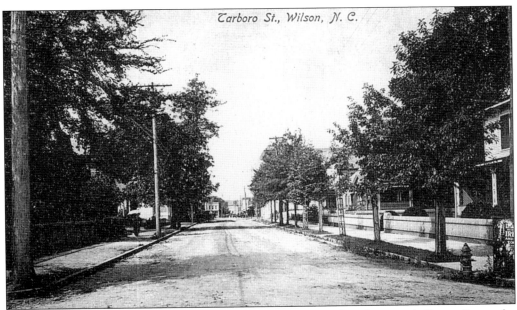

Tarboro St., Wilson, N. C.

This 1908 O.V. Foust card was taken at the intersection of Tarboro and Green Streets by the First Methodist Church, looking towards Nash Street. The whole block appears to be a residential area but it has been comprised of offices and businesses for a long time.

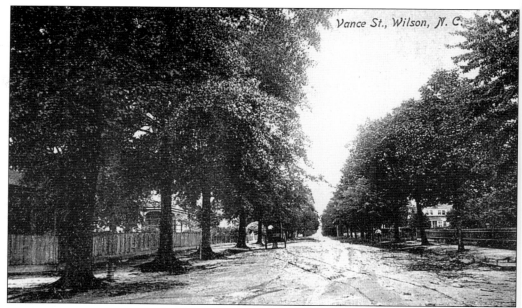

These two scenes represent the few postcards made of Vance Street, one of the older streets in the city. The top card, postmarked 1909, reads, "Hello Jim, How are you? You are sadly mistaken if you believe that I went to Annie's party, but I hear that you went. We have some mighty sweet teachers but not pretty. Why didn't you come to the hayride?" The bottom card is dated and postmarked 1908. Many homes in this time period had fences.

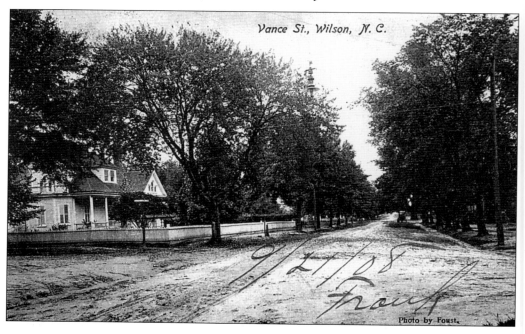

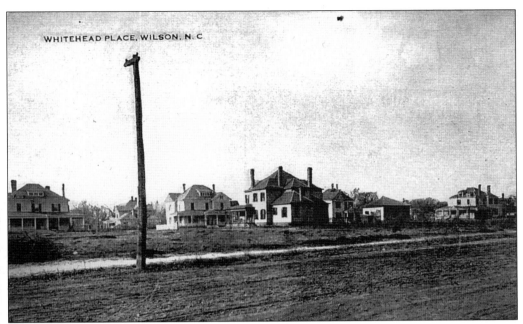

WHITEHEAD PLACE, WILSON, N. C.

Whitehead Place was one of the fashionable early-20th century neighborhoods of Wilson. It was located on Whitehead Avenue heading towards Atlantic Christian College from Nash Street. The land was originally owned by Howell Gray Whitehead and most of the above homes are still standing in the Old Wilson Historic District.

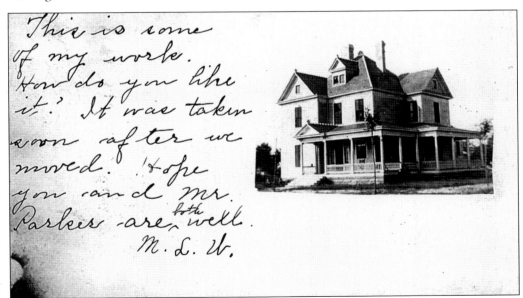

This 1907 real photograph postcard was sent to Mrs. George Parker in Camden, New Jersey. The house was built by the Wilkins Brothers and soon bought by the Hyman H. Walston family. It eventually became the Arts Council of Wilson for many years before they moved to the old Branch Bank building. The message reads, "This is some of my work. How do you like it? It was taken soon after we moved. Hope you and Mr. Parker are both well. MLW."

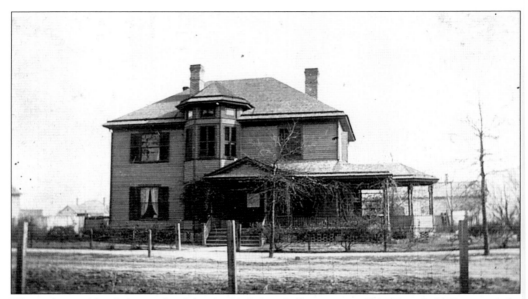

The early president's home for Atlantic Christian College was at 600 West Gold Street on the corner of Whitehead Avenue. This postcard also advertised the Foust Studio.

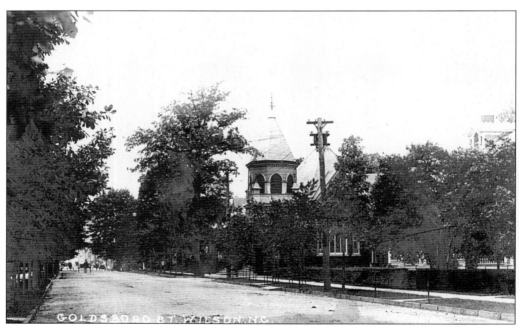

Here is a view of Goldsboro Street, showing the tower of the First Christian Church looking towards Nash Street.

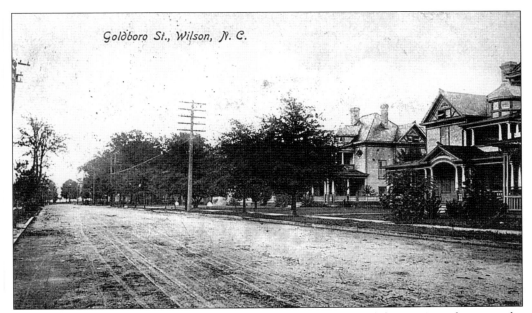

Goldboro St., Wilson, N. C.

This Goldsboro Street scene shows the Farmer house to the right and the Oettinger home on the left. It was owned by Cora and Sallie Farmer. The card was postmarked in 1909.

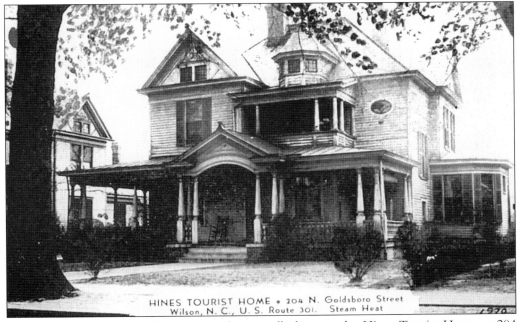

HINES TOURIST HOME ♦ 204 N. Goldsboro Street
Wilson, N. C., U. S. Route 301. Steam Heat

The Farmer house in the above postcard eventually became the Hines Tourist Home at 204 Goldsboro Street.

Varita Court Apartments are still standing in front of St. Timothy's Episcopal Church. They were designed by Tommy Herman, a local architect. The real photograph postcard was postmarked in 1930. Note the automobile parked straight in.

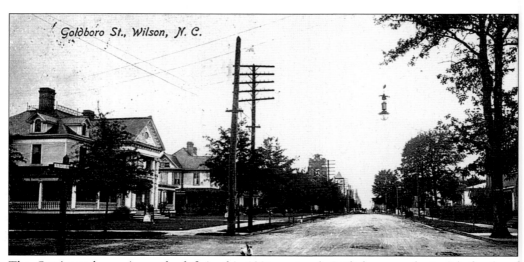

The Oettinger home is on the left in this 1906 postcard. Built by an early Jewish family of Wilson, it later became Wilson's Elks Lodge. The tower at the end of the street, apparently under construction, belongs to St. Timothy's Episcopal Church.

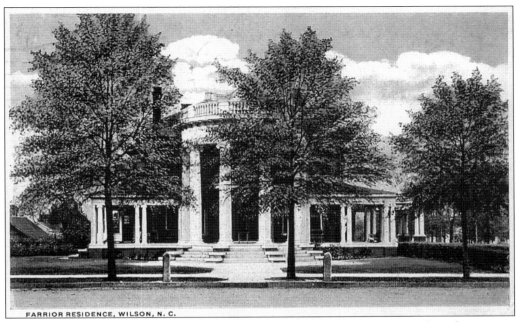

FARRIOR RESIDENCE, WILSON, N. C.

The Jefferson D. Farrior house was built by artisans brought over from Italy. There was a ballroom on the third floor. The home was torn down in the 1960s. The bottom photo shows the location of the Farrior home in relationship to Woodard Circle.

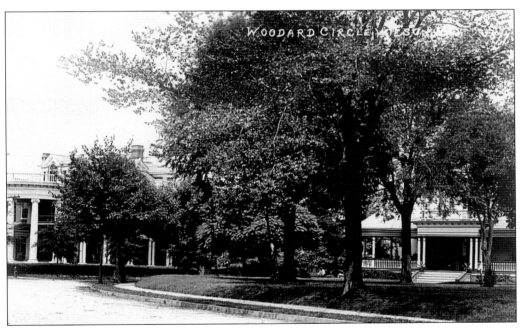

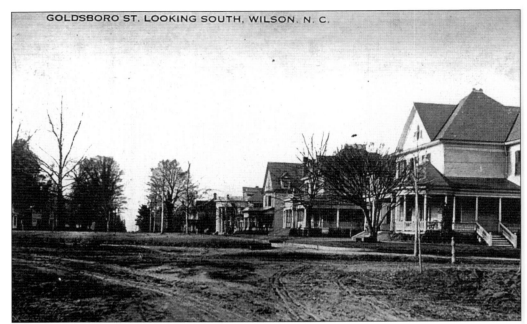

Woodard Circle and Goldsboro Street was another fashionable area in Wilson. In the top postcard, the Farrior home is fourth from the right. Woodard Circle now has a North Carolina highway historical marker for the Wilson Confederate Hospital, which was located at the Wilson Collegiate Institute and was located nearby on Academy Street.

Greetings from WILSON, N. C. North Goldsboro Street

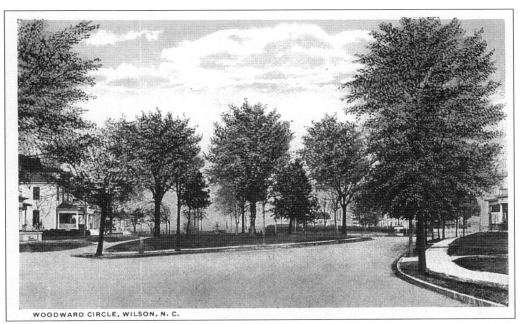

WOODWARD CIRCLE, WILSON, N. C.

Three Woodard families owned the houses to the left of Woodard Circle on land originally owned by Warren Woodard and his wife, Jerusha Farmer Woodard.

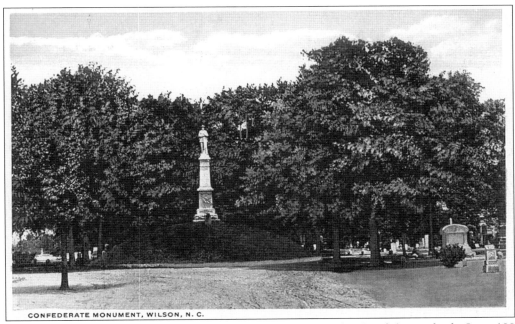

CONFEDERATE MONUMENT, WILSON, N. C.

The Confederate Monument was erected in 1902 to honor the Confederate dead. Over 100 unidentified bodies were moved from the original downtown cemetery to the mound for the monument. The bodies have recently been identified by Jerry Stancil of Stancil's Heating and Cooling. The bottom card was postmarked in 1908.

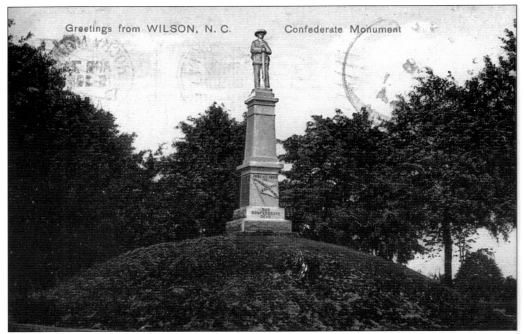

Greetings from WILSON, N. C. Confederate Monument

The bottom postcard (postmarked in 1922) shows the tombstone for Thomas Ruffin "Sprawls" Lamm (1840–1915) and his wife Nancy Thorn Lamm (1847–1925). He was one of the wealthiest men in Wilson and owned almost 1,200 acres of prime farmland and downtown property.

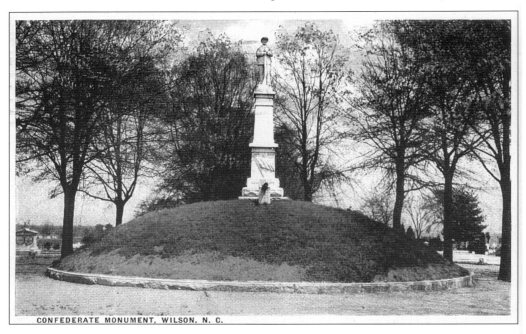

CONFEDERATE MONUMENT, WILSON, N. C.

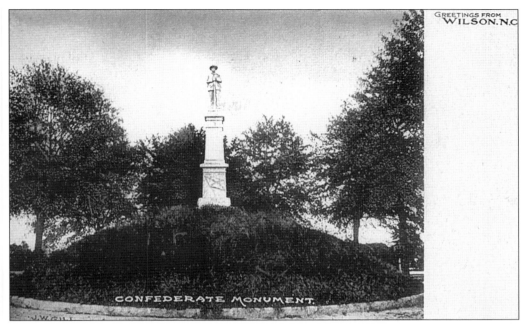

CONFEDERATE MONUMENT.

For many years on Confederate Memorial Day in May, the children from Margaret Hearne School would visit the monument with flowers for the dead. The John Dunham Chapter of the United Daughters of the Confederacy would give a program. Large crowds attended. The message on the bottom card, postmarked 1916, reads, "Dear Ellie, I am very sorry but I don't see any chance to go now. I know I would have a nice time. I have a date with the dentist Fri. night. I fooled him last week at the picnic at Rock Ridge so will have to go. Etta."

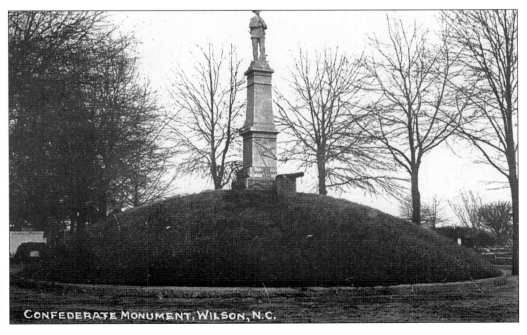

CONFEDERATE MONUMENT, WILSON, N.C.

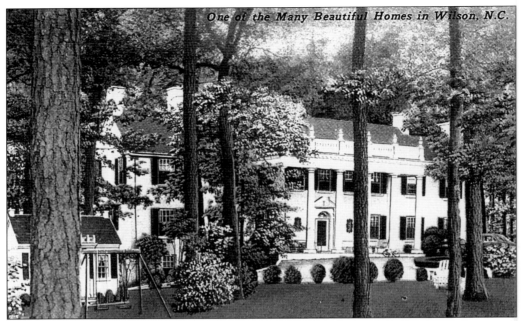

The Dr. and Mrs. Mallory A. Pittman home was designed by local architect Tommy Herman and built in 1938. The house cost $13,500 to construct; it is currently owned by Mr. and Mrs. Ralph Webb. The child's playground, to the left, was moved to the back yard.

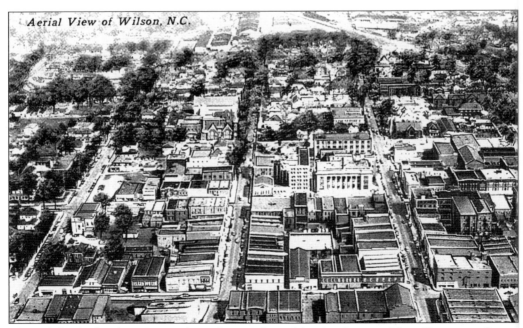

Aerial View of Wilson, N.C.

The rich land of Wilson County brought an influx of farming interest. The village grew from a handful of people to a prosperous city, often called one of the prettiest residential and downtown areas in the state.

Six
AGRICULTURAL AND
INDUSTRIAL

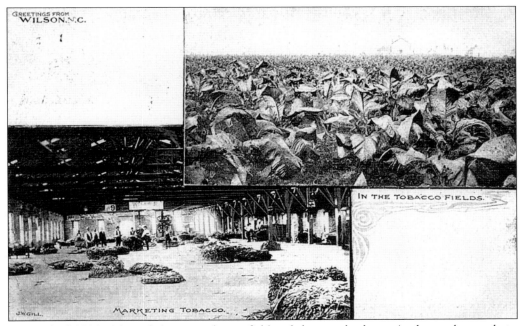

Postmarked 1906, this card shows a tobacco field and the cured tobacco in the market ready to sell. Wilson started its tobacco market in 1890 and by 1919 the town claimed it as the "World's Largest Bright Leaf Tobacco Market."

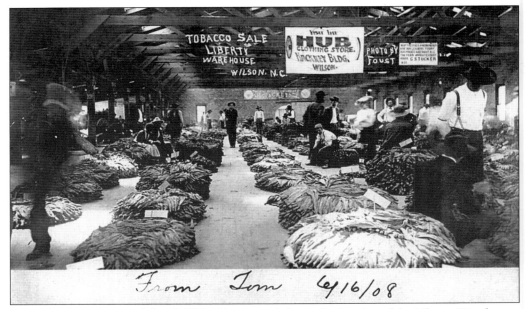

Taken by O.V. Foust and dated 1908, this postcard shows the interior of the Liberty Warehouse. Note the tied tobacco in layered, round piles. An advertisement for the Hub Clothing Store in the Hackney Building is hanging from a roof support.

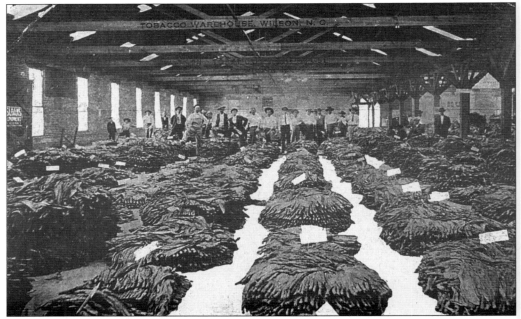

The message written March 10, 1910 on this card says, "Hello kids, why didn't you answer my letters I sent you and never heard from you? You ought to be down here. It looks like summer weather. Hot enough to make a fellow lazy. J.T.C."

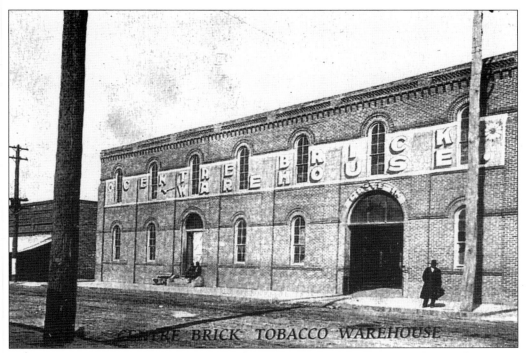

The Center Brick Warehouse was built in 1896 as the Watson Warehouse. The warehouse was later owned by Ula H. Cozart (1869–1948) and Joseph C. Eagles Sr. (1871–1952).

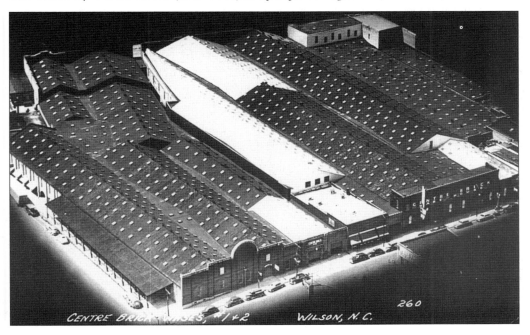

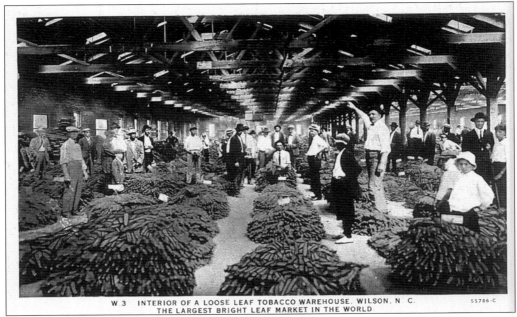

W.3 INTERIOR OF A LOOSE LEAF TOBACCO WAREHOUSE, WILSON, N.C.
THE LARGEST BRIGHT LEAF MARKET IN THE WORLD
55786-C

This card, postmarked in 1933, shows the interior of a Wilson tobacco warehouse. The message says, "Dear Mother, 70 miles to go and having our lunch. Had a wonderful trip so far and Helen and Myra have stood it very well. Great lots of wild flowers we have never seen before. Will write again from Myrtle Beach. With love, Bob."

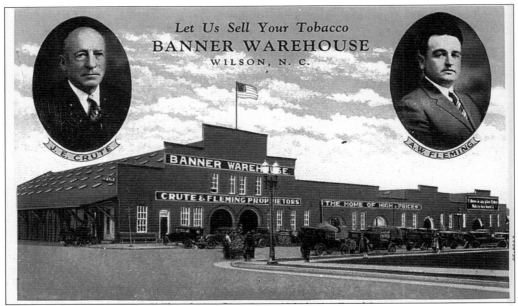

The Banner Warehouse advertised itself as "The Home of High Prices" and "If There Is Any Place Any Better, Nobody Has Found it." It was owned by J.E. Crute and Allie W. Fleming, two leaders in the tobacco market. Fleming stadium was named for Allie Fleming. James Edmundson Crute was from Mecklenburg County, Virginia.

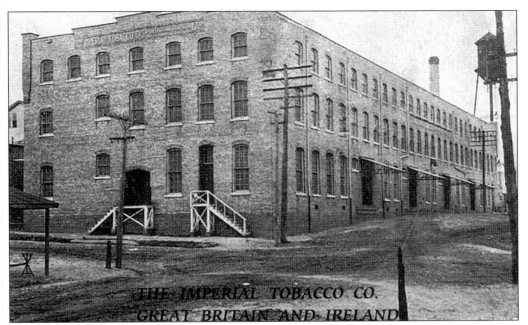

The Imperial Tobacco Company of Great Britain and Ireland was built in 1903 with Charles Mortimer Fleming (1862–1931) at its head. A native of Warren County, he had the honor of purchasing the first lot of tobacco sold on the opening day of the Wilson market in September 1890. He is often called "Grandfather of the Wilson Tobacco Market."

This early photograph of an industrial building is probably the Wells-Whitehead Tobacco Company. The message on the back says, "This is a scene of Wilson, they don't think enough of it to put the name on it." This company made cigarettes named "Wilson Straight Cuts," "Carolina Brights," and "Egyptian Princess." The Ware-Kramer Company produced "White Roll" cigarettes and the Erwin-Nadal Tobacco Company produced "Contentnea & Plon Plon" cigarettes, all in Wilson.

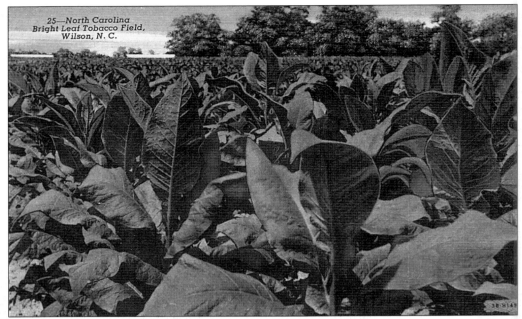

25—North Carolina
Bright Leaf Tobacco Field,
Wilson, N. C.

Tobacco fields were everywhere in Eastern North Carolina. The leaf made much money for the farmer and community. After suffering through economic hard times during the Reconstruction Era and poor cotton prices, tobacco brought a boost to the economy in 1890.

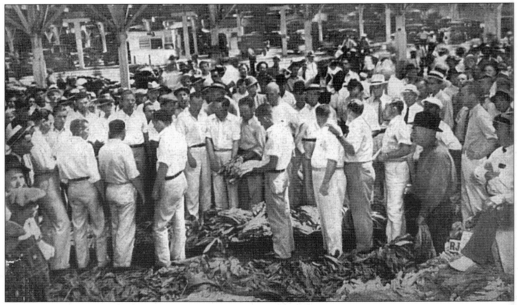

This 1950s photograph shows a tobacco auction in progress. The auctioneer, ticket market, tobacco buyers from assorted companies, United States Federal tobacco graders, and farmers are seen working together. J.R. Boykin Jr. is on the front row, fourth from the left, facing left. He was a U.S. Government Tobacco Inspector for over 20 years and later owner of Gold Leaf Warehouse in Wilson.

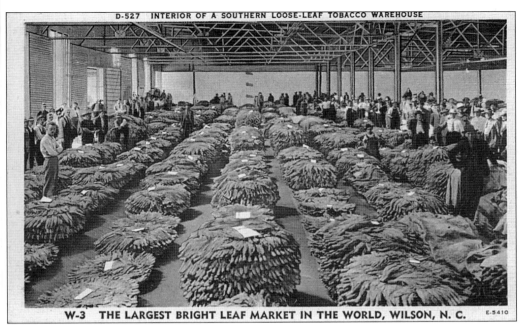

D-527 INTERIOR OF A SOUTHERN LOOSE-LEAF TOBACCO WAREHOUSE

W-3 THE LARGEST BRIGHT LEAF MARKET IN THE WORLD, WILSON, N. C. E-5410

The bottom card reads, "We left home at 4 am. Beautiful weather and good roads. Some spring flowers here and there. We had dinner in Wilson. Didn't see any tobacco but saw the big sheds. Love to all. E." It is postmarked March 2, 1956. The top card is postmarked in 1955 and shows farmers milling around the warehouse waiting for the tobacco auction to start.

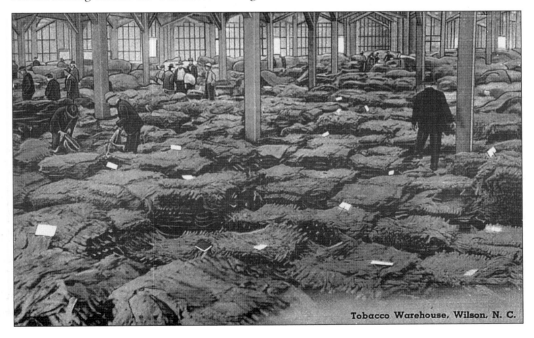

Tobacco Warehouse, Wilson, N. C.

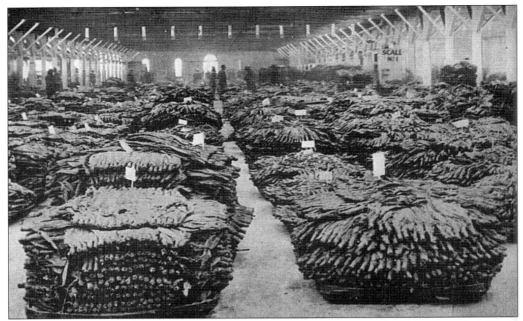

This warehouse scene shows the amount of work it took to get the tobacco crop to market. Fall was an exciting time in Wilson as people brought their crops to sell, visited friends, and conducted business.

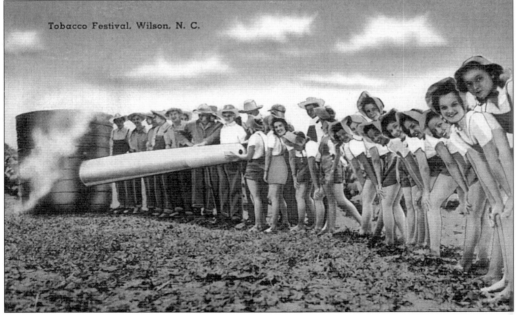

Tobacco Festival, Wilson, N. C.

The message printed on the back of this card says, "This view shows the world's largest pipe smoked by beautiful Wilson girls during the North Carolina Tobacco Exposition and Festival held annually in Wilson." The "Tobacco Festival" began in the mid-1930s and lasted until World War II.

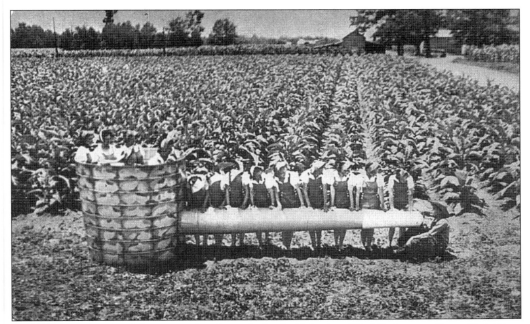

This postcard has the following printed on the back: "Testing World's Largest Corn Cob Pipe, Wilson, NC. World's Largest Tobacco Market." The citizens of Eastern North Carolina looked forward to the Tobacco Festival and its parades, beauty pageants, dances, and contests.

This aerial photograph shows the Banner Warehouse and Tobacco Warehouse historic district from the water tower. Banner Warehouse was on Tarboro Street at the corner of Kenan Street. The water tower is next to Charles L. Coon High School.

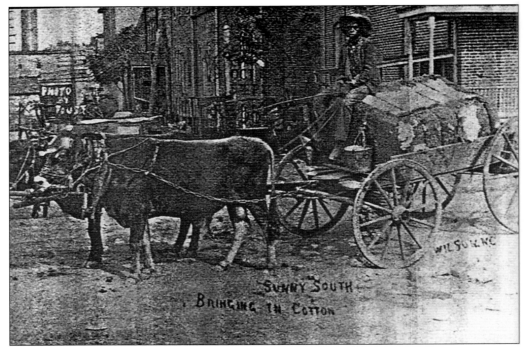

This Foust photograph shows a Wilson County farmer bringing in his cotton with a pair of oxen hitched to a wagon. Cotton was the big crop before tobacco replaced it. There were several failing cotton crops in the late 1880s and tobacco offered a great economic relief.

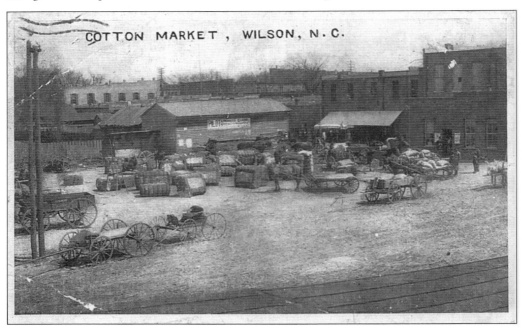

Postmarked in 1911, this postcard shows the Barnes–Davis Cotton Yard. Cotton has come back in recent years as a major Wilson County crop.

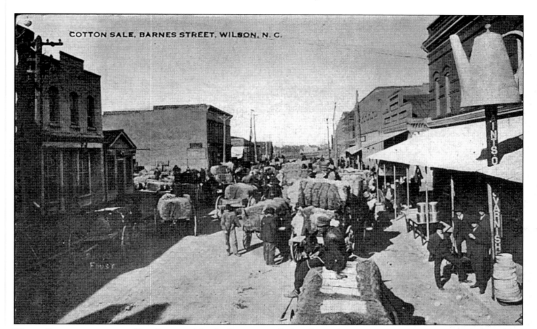

Here farmers are seen lined up with their cotton bales for sale on Barnes Street. P.L. Woodard Farm Supply is the furthest building on the left. The Coffee Kettle on the right advertised for an unidentified business that sold paints and varnishes. Cheese in large hoop containers is next to the advertising pole.

This scene shows baskets of cotton that had been picked that day. The baskets were big and often whole families picked cotton. The message on the back says, "Say Spot! If you can't be good, be careful. JSM." The card was postmarked in 1907.

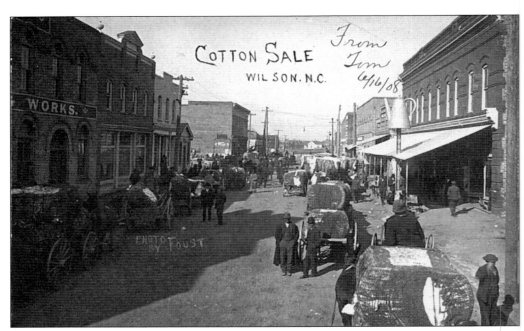

Seen here is a cotton sale on Barnes Street. The photograph is by O.V. Foust.

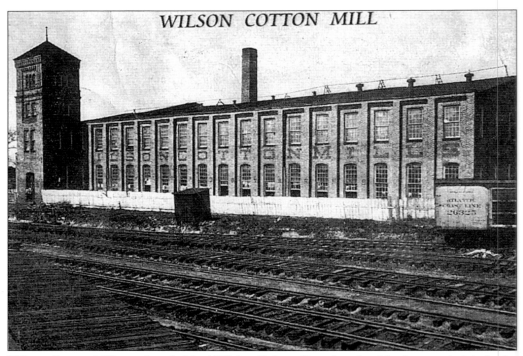

Wilson Cotton Mill was founded in 1882 by Alpheus Branch, a local business and civic leader and founder of Branch Bank.

This Farmers Cotton Oil Company advertising card shows company president Furman N. Bridgers (1878–1956) walking through a cotton field. The company was founded in 1904. His three sons ran the company after his death and sold it to Kaiser Chemical in 1966.

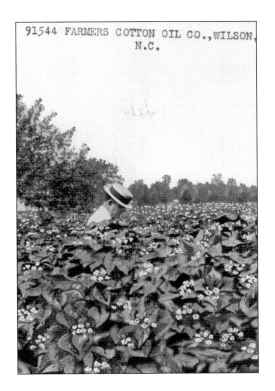

91544 FARMERS COTTON OIL CO., WILSON, N.C.

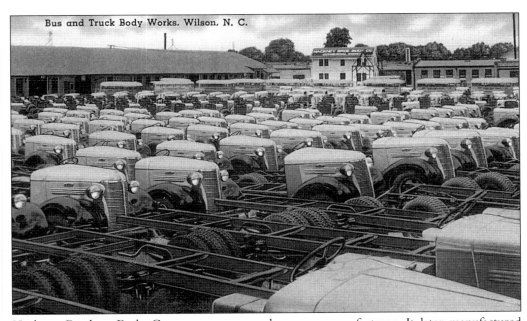

Bus and Truck Body Works, Wilson, N. C.

Hackney Brothers Body Company was an early wagon manufacturer. It later manufactured school buses and refrigerated trucks. Founded in 1852, this was one of Wilson's oldest industries. They closed in the late 1990s.

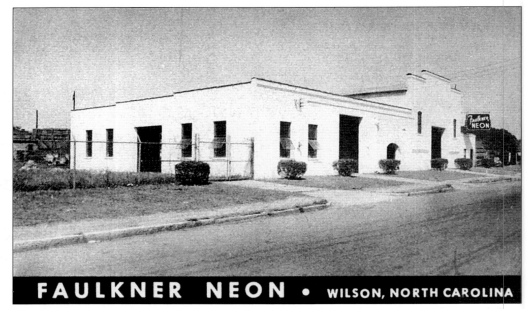

FAULKNER NEON • WILSON, NORTH CAROLINA

Faulkner Neon on East Barnes Street designed and manufactured neon signs and serviced them as well. The phone number was 4056.

The only Suckers we have in Wilson.

The hog industry has always had a big role in Wilson County, as the pig was the main part of Wilson citizen's diet in the 18th and 19th centuries. In more recent years, the Eastern North Carolina style of barbecue, which uses a vinegar base, has sustained the hog industry and brings in many tourists for a sumptious feast.

Seven

AROUND TOWN

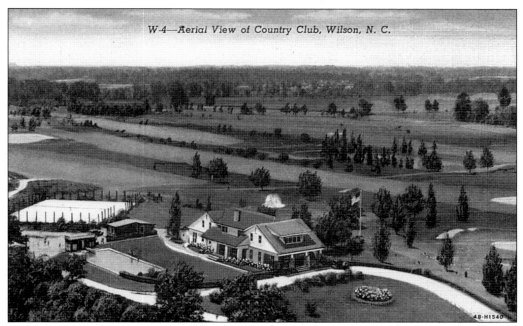

W-4—Aerial View of Country Club, Wilson, N. C.

This is an aerial view of the Wilson Country Club, founded in 1917 and said to be the only golf course between Richmond, Virginia and Charleston, South Carolina. The Wilson Country Club moved to a new site in the 1970s and the old club was renamed Willow Springs.

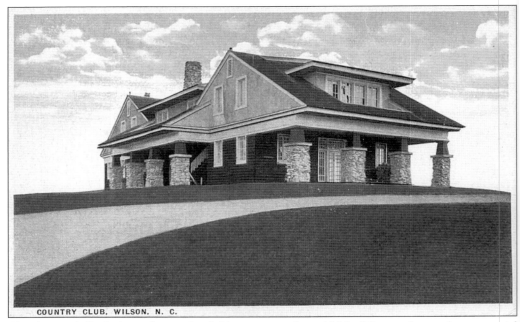

COUNTRY CLUB, WILSON, N. C.

The Arts and Crafts bungalow-style clubhouse was a beautiful building and served many social events for the Wilson community. Nestus Freeman, a noted Wilson stonemason, did the stonework columns for the clubhouse.

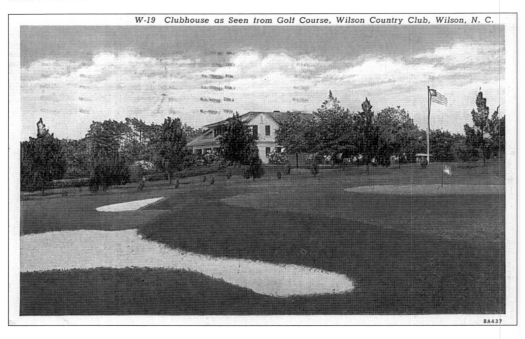

W-19 Clubhouse as Seen from Golf Course, Wilson Country Club, Wilson, N. C.

8A437

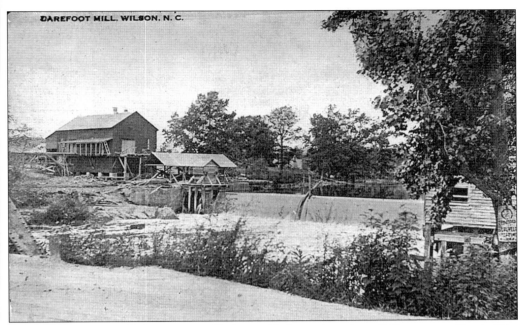

Barefoot Mill, later called Wiggins Mill, is an old damned section of Contentnea Creek. The Barefoot community also had a Methodist church and school. The top card, postmarked 1911, was misnamed Darefoot Mill. The bottom card, postmarked 1906, has a message that reads, "Have traveled about 500 miles over this stricken state the first three days. Nothing to be seen between the towns except cotton and tobacco and a few huts."

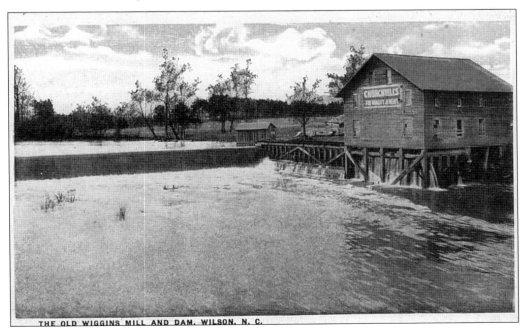

THE OLD WIGGINS MILL AND DAM, WILSON, N. C.

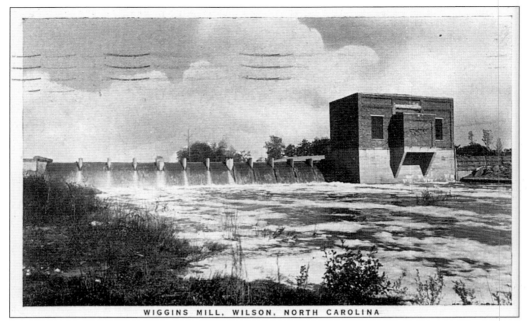

WIGGINS MILL, WILSON, NORTH CAROLINA

Dated October 23, 1939, this card shows the dam and power plant at Wiggins Mill, which looks very much like this today.

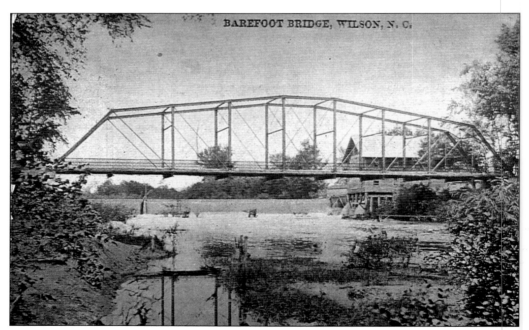

BAREFOOT BRIDGE, WILSON, N. C.

The only metal truss bridge in Wilson County was at Barefoot Bridge (later Wiggins Mill). The mill and dam are in the background.

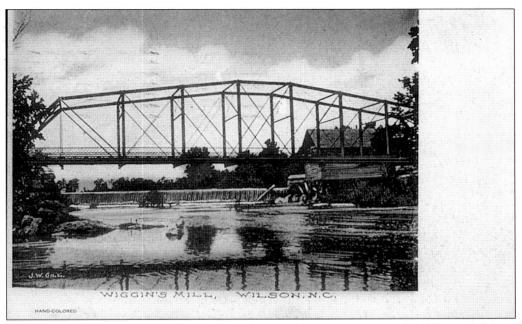

The message on the back of the top card, dated December 16, 1907, states, "Tell Papa I will look for him soon Wed. eve. And for him not to disappoint me. I want you to send me your vail [sic] to wear home. I know it will be cold. I certainly want to go home now as bad as I did when I was at the Exposition (Jamestowne). Etta." Both cards shows the metal bridge over Contentnea Creek. It was earlier called Barefoot's Bridge and later called Wiggins Mill.

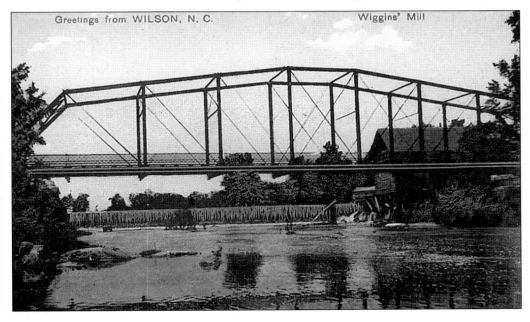

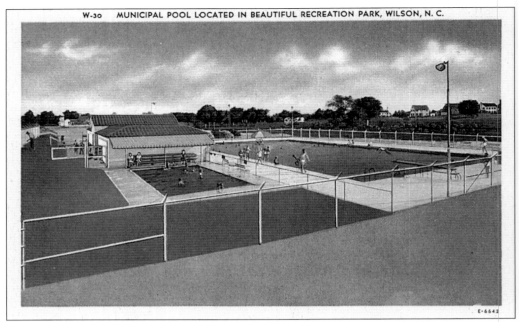

The swimming pool at Recreation Park was built in the 1940s and was the center of youth activities for many generations. Burt Gillette was the longtime director and under his guidance Wilson was noted for its recreation program. The pool now has a bubble for winter-time use.

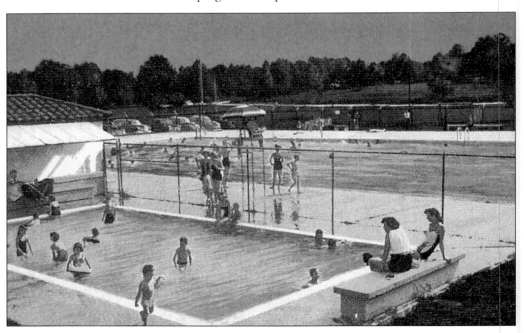

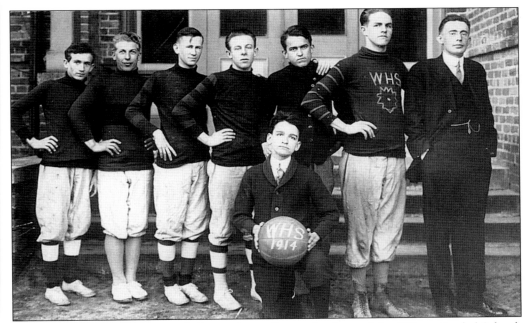

The Wilson High School basketball team is standing at the front of the Wilson Graded School, later named for Margaret Hearne. From left to right are Harvey Magett, Moses Dew, Robert Moss, Al Branch, Stewart Davis, Willie Wray, Mr. Mann, and Will Fleming. They are holding a ball dated 1914.

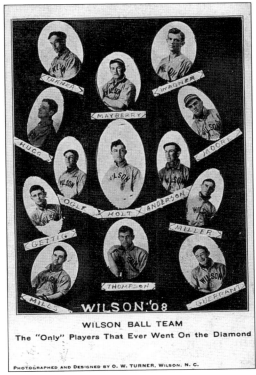

WILSON BALL TEAM
The "Only" Players That Ever Went On the Diamond

PHOTOGRAPHED AND DESIGNED BY O. W. TURNER, WILSON, N. C.

This 1908 picture of the Wilson Ball Team states them as "the only players that ever went on the Diamond." It was photographed and designed by O.W. Turner and printed by Snakenberg Brothers. From top to bottom on the left are (surnames only) Turner, Hugg, Gelting, and Mills. In the center are Mayberry, Boyle, Holt, Anderson, and Thompson. On the right side are Wagner, Moore, Miller, and Guerrant.

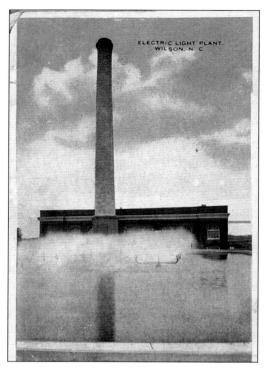

The Electric Light Plant is located on the backside of Maplewood Cemetery. A mist can be seen on the postcard coming from the water. The City of Wilson no longer makes its own electricity. The building still stands and is used by the City for storage.

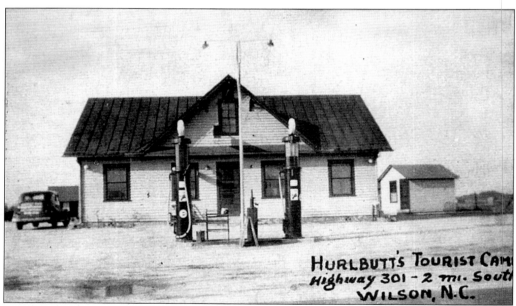

The back of this card (dated October 23, 1939) reads, "Dear daughter, Here is where we are stopping tonight. You can see the pretty little houses behind the gas station. The lady at the station cooked our dinner tonight as we were 2 miles from any restaurant. We are about 500 miles from Jacksonville, Fla. and hope to make it in 2 days. Am feeling fine only very tired. Love to all, Mother and Dad."

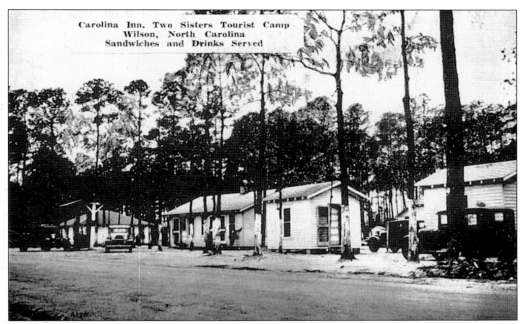

The Carolina Inn and Two Sisters Tourist Camp are examples of the typical early tourist stops that eventually evolved into the motel system we have today across America. Highway 301 was a busy north/south highway going from Maine to Florida.

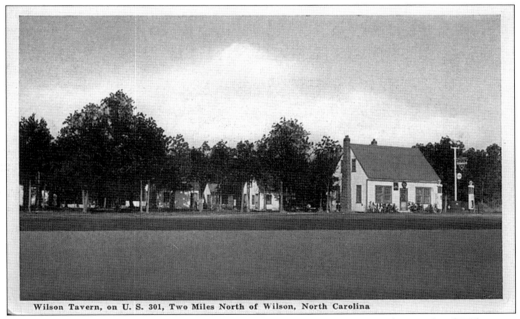

The Wilson Tavern was also a tourist camp and service station two miles north of Wilson on U.S. Highway 301. Postmarked in 1941, this card was made by Graycraft Card Company of Danville, Virginia.

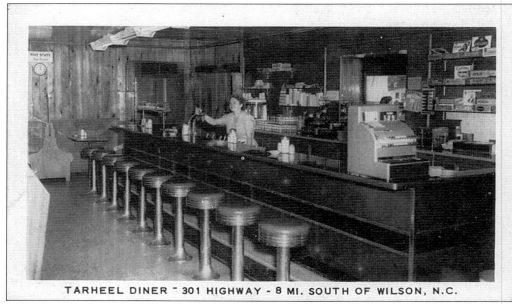

TARHEEL DINER - 301 HIGHWAY - 8 MI. SOUTH OF WILSON, N.C.

This shows the rare interior of a 1950s diner. It is located on Highway 301, south of Wilson and close to Lucama, North Carolina. They specialized in home cooking. Note the 1950s motif with knotty pine paneling.

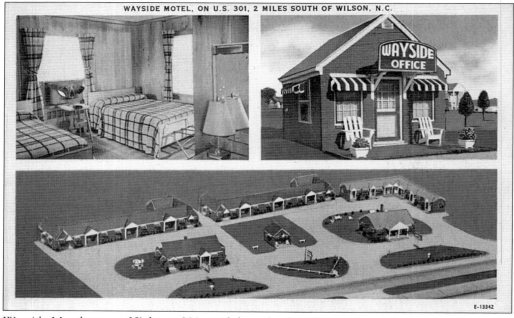

Wayside Motel area on Highway 301-south later developed into a motel district. Owned by Mr. and Mrs. W.E. Minshew, the motel was advertised as two miles south of Wilson. Note the rare view of an interior room.

116

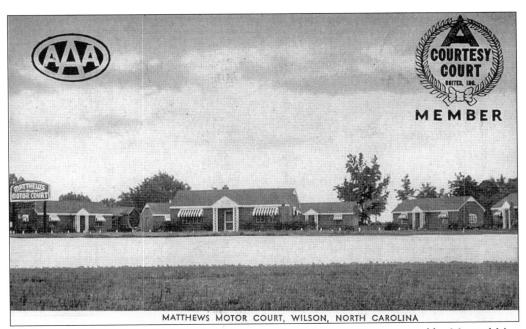

MATTHEWS MOTOR COURT, WILSON, NORTH CAROLINA

Matthews Motor Court had 16 comfortable, steam-heated rooms. It was owned by Mr. and Mrs. C.T. Matthews. It is an ongoing business today.

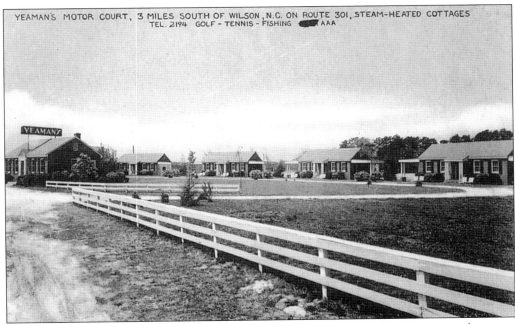

YEAMAN'S MOTOR COURT, 3 MILES SOUTH OF WILSON, N.C. ON ROUTE 301, STEAM-HEATED COTTAGES
TEL. 2194 GOLF - TENNIS - FISHING AAA

In a card dated 1948, Yeaman's Motor Court advertised "pine-paneled rooms, simply super-beautiful. A carport with white lattice work so that one can step from their room into their car."

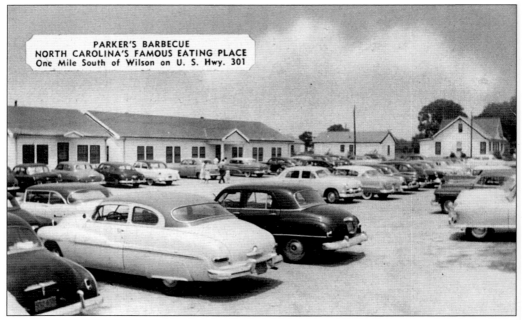

PARKER'S BARBECUE
NORTH CAROLINA'S FAMOUS EATING PLACE
One Mile South of Wilson on U. S. Hwy. 301

Parker's Barbecue, founded in the 1940s by the Parker Brothers, is known across the United States for its fried chicken, barbecue, slaw, boiled potatoes, Brunswick stew, cornmeal corn bread sticks, hush puppies, and sweet tea. Besides Parker's, there are several other noted barbecue restaurants including Bill's Barbecue, Cherry's Barbecue, and Mitchell's Barbecue.

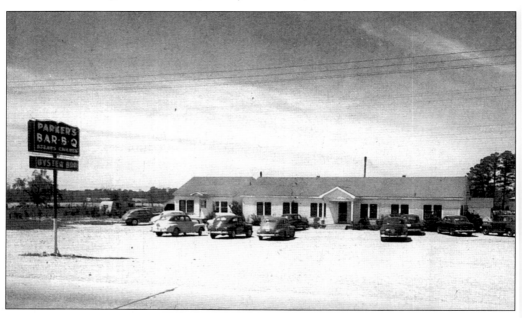

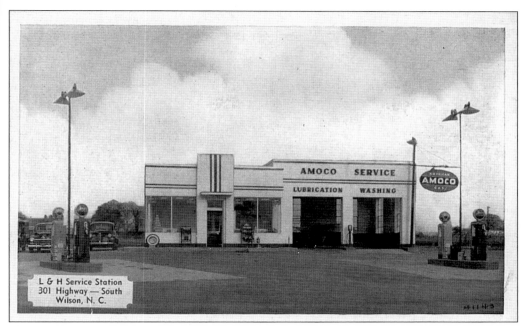

The L&H Service Station is typical of 1930s service stations and sold Amoco gas. Owned by Champ C. Lucas and J.B. Honeycutt, it was built in the Art Deco style.

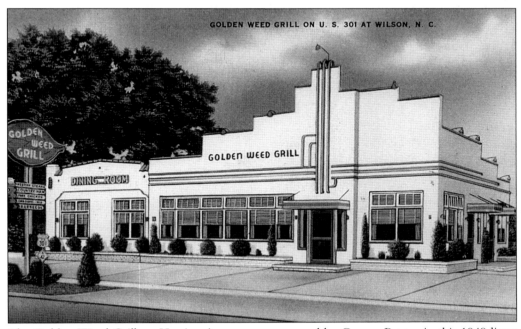

The Golden Weed Grill on Herring Avenue was managed by George Pappas in this 1949 linen postcard. It remained as a restaurant for a long time. The Art Deco style building still stands but has had major changes to the front.

This greeting card from Elm City says on the front, "Sporting in Elm City, Hugging by another man would be squeezing just the same." Elm City was founded in 1873 as Toisnot. The name was changed to Elm City in 1891 and changed back to Toisnot in 1895. It was changed once again to Elm City in 1913, which it has remained.

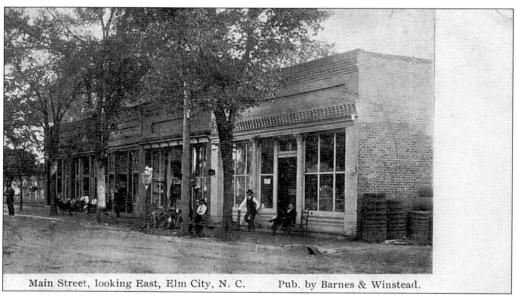

Main Street, looking East, Elm City, N. C. Pub. by Barnes & Winstead.

This Elm City Main Street scene shows the R.S. Wells Store on the right. The card was published by Barnes & Winstead, local Elm City photographers. Redmond Stanley Wells, born in 1848, was a longtime merchant and founder and president of Toisnot Banking Company in 1901. He owned over 1,500 acres of land.

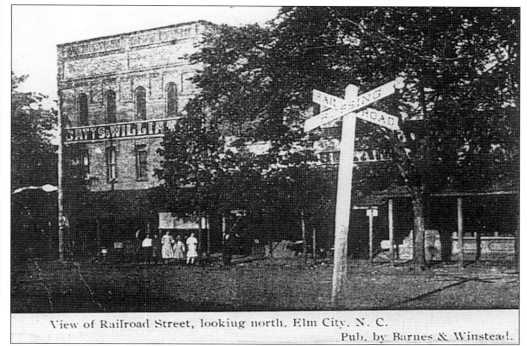

View of Railroad Street, looking north. Elm City. N. C.
Pub. by Barnes & Winstead.

This is a view of Railroad Street looking north. The Batts and Williams Livery Stable is to the left.

Toisnot Banking Company was founded in 1901, with R.S. Wells as president. The Bank of Elm City, a competing bank, had been incorporated in 1898 by John L. Bailey. Bailey served as North Carolina legislator for several terms.

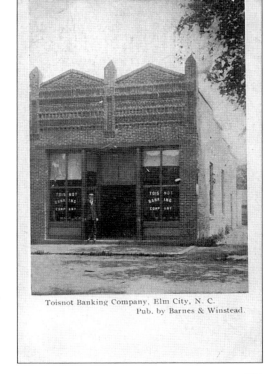

Toisnot Banking Company, Elm City, N. C.
Pub. by Barnes & Winstead.

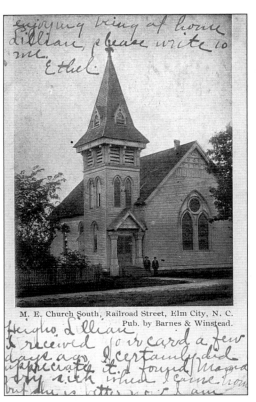

M. E. Church South, Railroad Street, Elm City, N. C.
Pub. by Barnes & Winstead.

The Elm City Methodist Church was constructed in 1884. The first church was built in 1873 at another site. This building was razed and a brick church was built for the Methodist congregation.

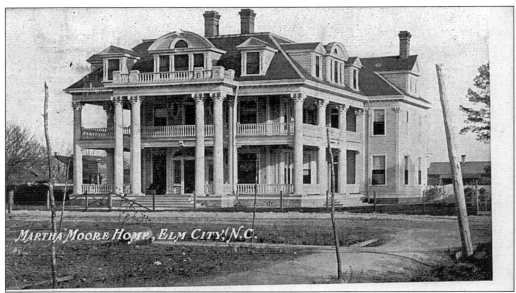

MARTHA MOORE HOME, ELM CITY, N.C.

The Dr. Edwin Gibbons Moore (1861–1931) home was the residence of a popular Elm City physician. It was built in 1903 as the Elm City Graded School and sold a year later to Dr. Moore, who used it as a private hospital and named it the Martha Moore Home, after his mother. He later turned it into a residence and called it Durant Hall. The home was razed in the 1970s.

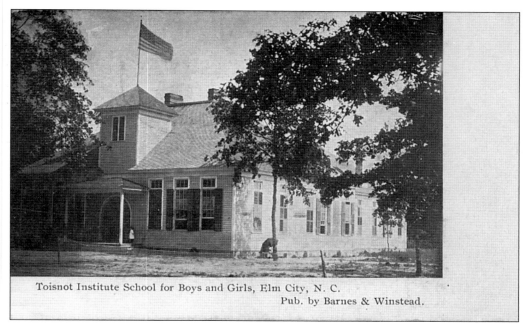

Toisnot Institute School for Boys and Girls, Elm City, N. C.
Pub. by Barnes & Winstead.

These are two views of the Toisnot Institute, which later became the Elm City Graded School. Many local citizens were educated in this building and it was considered to be an outstanding educational institution for this area.

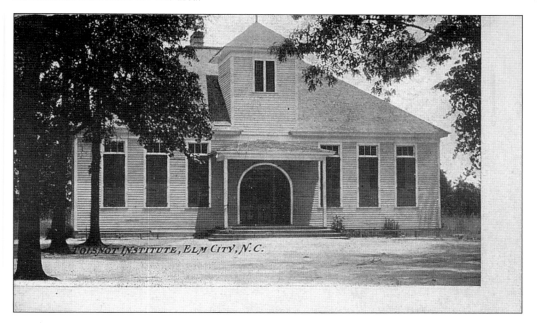

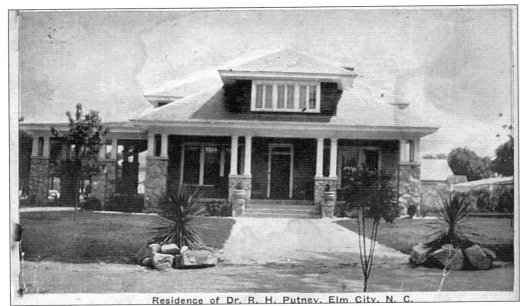

Residence of Dr. R. H. Putney, Elm City, N. C.

The Dr. Robert Hubbard Putney (1889–1953) home was built in the bungalow style in 1920 by C.C. Rackley of Wilson. The Elm City residential area was considered beautiful and, with a major highway and railroad, was a bustling little town. The message reads, "I appreciate your card so much. It's been a long time though. Each day I would answer tomorrow. We are having beautiful spring weather in winter. Has been so mild. This picture was made about 9 years ago. Lots of changes in my yard since. Love to each of you. Ruth." The card is postmarked January 27, 1932.

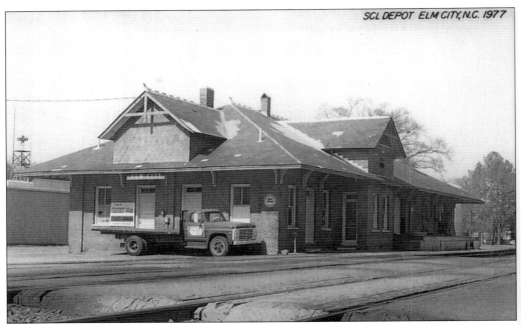

SCL DEPOT ELM CITY, N.C. 1977

The Elm City Depot was a busy train station for many years. Built in 1909, it is still standing.

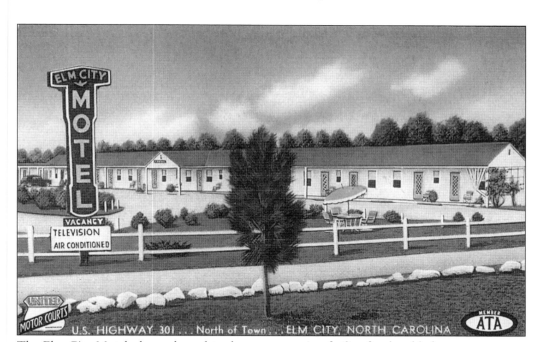

The Elm City Motel, shown here, later became a nursing facility for the elderly.

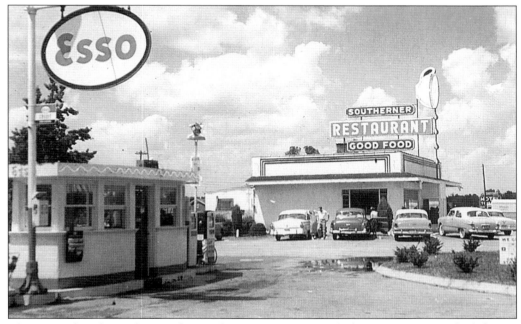

This 1950s shot shows the popular Southerner Restaurant with the Esso Station to the left.

Black Creek was incorporated in 1871 but had long been a community beginning in the early 1800s. This greeting card is typical of the penny postcard send by the general public.

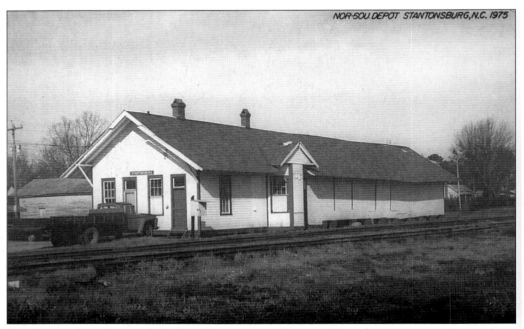

The Stantonsburg Depot, built in 1907, is an excellent candidate for restoration. Stantonsburg was incorporated in 1818 and is the oldest town in Wilson County.

Lucama was incorporated in 1891 and named for the first two letters in the names of Josephus Daniels's brother's wife and two sisters: Lulie, Carrie, and Mary Borden. Daniels was reared in Wilson and later became Secretary of the Navy under Roosevelt and was Ambassador to Mexico. His mother, Mary Cleves Daniels, was postmistress in Wilson for many years. the message reads, "Hello stranger, I certainly would like to see you some and hold your hand. Someone told me you were getting prettier every day. I don't see how that could be. DBM."

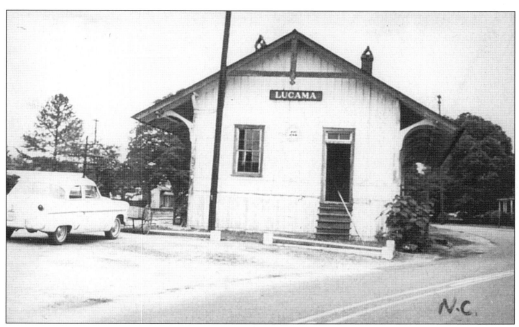

The Lucama Depot, built in 1904, has been restored as an office for an oil company.

INDEX